See it Again, Say it Again

The Artist as Researcher

Janneke Wesseling (ed.)

D1628196

Antennae
Valiz, Amsterdam

With contributions by

Jeroen Boomgaard
Jeremiah Day
Siebren de Haan
Stephan Dillemuth
Irene Fortuyn
Gijs Frieling
Hadley+Maxwell
Henri Jacobs
WJM Kok
Aglaia Konrad
Frank Mandersloot
Aernout Mik
Ruchama Noorda
Vanessa Ohlraun
Graeme Sullivan
Moniek Toebosch
Lonnie van Brummelen
Hilde Van Gelder
Philippe Van Snick
Barbara Visser
Janneke Wesseling
Kitty Zijlmans
Italo Zuffi

See it Again, Say it Again:
The Artist as Researcher

Janneke Wesseling (ed.)

See it Again, Say it Again: **1**
The Artist as Researcher
Introduction
Janneke Wesseling

The Use and Abuse of 17
Research for Art and Vice Versa
Jeremiah Day

Art Research **23**
Hilde Van Gelder

Visual Contribution 41
Aernout Mik

Absinthe and Floating Tables 51
Frank Mandersloot

The Chimera of Method **57**
Jeroen Boomgaard

Reform and Education 73
Ruchama Noorda

The Artist as Researcher **79**
New Roles for New Realities
Graeme Sullivan

Visual Contribution 103
Aglaia Konrad

Some Thoughts about Artistic 117
Research
Lonnie van Brummelen
& Siebren de Haan

Surface Research **123**
Henri Jacobs

The Artist's Toolbox 169
Irene Fortuyn

Knight's Move **175**
The Idiosyncrasies of Artistic Research
Kitty Zijlmans

In Leaving the Shelter 193
Italo Zuffi

Letter to Janneke Wesseling **199**
Vanessa Ohlraun

Painting in Times of Research 205
Gijs Frieling

Visual Contribution 211
Philippe Van Snick

The Academy and **221**
the Corporate Public
Stephan Dillemuth

Fleeting Profundity 243
Moniek Toebosch

And, And, And So On 249
and So Forth
WJM Kok

A Blind Man Sometimes Hits **255**
the Crow
Barbara Visser

Acknowledgments **269**

Contributors **273**

Index of Names **289**

Index of Subjects **295**

Colophon ... **301**

See it Again, Say it Again: The Artist as Researcher
Introduction

Janneke Wesseling

'Research' is a buzz-word on the international art scene. People everywhere are talking about 'the artist as researcher' and debating how research in art relates to academic research. These discussions often revolve around the legitimisation of research in art within an academic framework and it is primarily theoreticians, not the artists, who are driving them. This book is an attempt to change this. It approaches the phenomenon of 'research *in and through* art' (to use the most correct and complete term) from the perspective of the visual artist and through the prism of artistic practice. Most of the authors are visual artists themselves and the contributions by theorists also focus on the practice of the artist as researcher.

The exceptional thing about research in and through art is that practical action (the making) and theoretical reflection (the thinking) go hand in hand. The one cannot exist without the other, in the same way action and thought are inextricably linked in artistic practice. This stands in contradistinction to 're-search *into* art', such as art history and cultural studies.

Master's courses in the field of research in art are now on offer in various European cities and artists can gain a doctorate at a growing number of universities. This has long been the case in the United Kingdom, but for most European countries it is new. We can justifiably speak of an 'educational turn in art' and an 'artistic turn in academic education'.[1]

Political decision-making has thereby given concrete impulses to the institutionalisation of research

in art. However, the phenomenon of research in art is nothing new. The idea of art-as-research flows from *art itself*, in particular from the conceptual art of the 1960s onwards. Conceptual artists oppose the view that art can be viewed in isolation from history and politics, and they assert that art is necessarily cognitive.

In the post-modern era, reflection and research are closely interwoven with artistic practice. In some cases the research has become the work of art itself; subject matter and medium serving as an instrument in the research or 'thought process'. Artists are increasingly positioning themselves in the societal and artistic field as researchers.

This book aims to offer various points of departure for the advancement of the debate about the positioning of research in art, in the art world as well as at universities. The intention is to inspire artists, art students and lecturers to undertake a critical reflection on their own practices and to promote awareness of research praxis by presenting practical examples.

Research and the Public Domain

The artist-as-researcher distinguishes himself from other artists by taking it upon himself to make statements about the production of his work and about his thought processes. The artist-researcher allows others to be participants in this process, enters into

1 These developments are a direct consequence of the Bologna Agreements and the Europe-wide reorganisation of education, aimed at establishing a comparable BA and MA framework for all European countries.

3

a discussion with them and opens himself up to critique. This is by no means self-explanatory; it actually represents a radical shift in the conception of 'artistry'. After all, the romantic view of the artist as a recluse in a studio from which he or she sends messages out into the world was prevalent until far into the 20th century.

The artist-researcher seeks the discussion in the public domain. 'For research to be research it has to be debated in the public domain', as Sarat Maharaj remarked.[2] This might happen at art academies and at art institutes, as well as at universities. When the discussion takes place in an academic context, within the framework of research for a PhD, then certain conditions are attached. For example, the research needs to yield fresh insights, not merely into one's personal work but for art in a broader sense as well. Crucial is the academic opponent, whose task it is to critically evaluate the new contribution to the artistic domain. If the research fails to produce novel insights, then there is no justification for the research project to lead to an academic dissertation.

There is a wide range of views about the nature of this dissertation as well as a diversity of opinion about the requirements to which it can be subjected, as is also demonstrated by the contributions to this volume. However, almost everyone concurs that language somehow plays an important part in research in art. Without language it is impossible to enter into a discourse, so the invention of a language in which we

can communicate with one another about research in art and through which we can evaluate the research is probably more important than devising a viable research methodology.

When asked about their reasons for embarking upon doctoral research, the response of almost all the artist-researchers is that their aim is to be part of a research community where they can share their thoughts with others and receive constructive, substantive criticism about their work. This research community represents a significant expansion of the possibilities for art and its practitioners, as well as a broadening of art discourse.

Art as (Self-)Critique

The age-old Western paradigm of art as mimesis, that is as imitation of the world, and as an expression of the close unity of the beautiful and true, came to an end around 1800. Friedrich Hegel thought that art had met its apotheosis, by which he of course did not mean that no more art would be produced or that our visual tradition had suddenly come to an end. For Hegel, the end of art meant that art could no longer be seen as the manifestation of truth and that the depiction of the divine, or of the divine in creation, was no longer self-explanatory.

Hegel's cogitations coincided with the emergence of an historical awareness, which is by defini-

2 At a symposium about research in art, held as part of 'Manifesta 8' in Murcia, Spain, in 2010.

tion also a critical awareness. Henceforth it would be evident that, because of the diversification of modern life and the increasing fragmentation of what was once a single, all-encompassing worldview, it was impossible for any work of art to continue being the rendering of a *totality*. In art, this new critical awareness assumed a clear-cut form from the second half of the 19th century.

Artists emancipated themselves from the classical tradition and positioned themselves as autonomous creators. One of the ways in which they did this was by responding in an overtly discursive manner to works of art by others. There are many well-known examples of this new, critical attitude: Manet and Titian, Cézanne and Rubens, Picasso and Velázquez, and so on. This critical discursivity represents a shift away from the centuries-old tradition of pupils emulating their masters. By degrees attention shifted from the interpretation of the work of art as a reproduction of reality to the interaction, the active dialogue, between the work of art and the social and historical context in which it was created and the work's beholder. Modern art, which was no longer representational, became self-critical.

In critical terms, modern art took aim at the societal and political fields, and at itself. The artist places every work of art in the context of other works of art, it is *positioned* vis-à-vis other works of art. This does not imply that those other works of art are literally identifiable in the new work (though that may be the case). Works of art embody a meta-element,

6

a conceptual moment; the work of art is 'aware' of itself, of its own position. One might term this the 'self-awareness' of works of art, which question and comment on themselves and the art of others.

From the 1960s, critique and self-reflexivity were a deliberate strategy in art — take, for example, conceptual art, Fluxus, appropriation art, institutional critique and so on. Artists claimed a discursive space for themselves. However, almost immediately this discursive space came under huge pressure from market forces and the for-profit mentality. In the USA and the UK this shift came about in the late 1970s with the governments of Reagan and Thatcher, twhich were the starting shot for the rise of the art market and, in its wake, a resurgence in traditional, figurative painting. 'Wir wollen Sonne statt Reagan ('We want sun instead of Reagan'), sang Joseph Beuys.

Since the fall of the Iron Curtain, neo-liberalism has been the prevailing ideology in Western countries and across whole swathes of the non-Western world, and the laws of the market have apparently gained universal currency. Artists are expected to operate as 'cultural entrepreneurs' in the market and within a cultural industry that is to large extent fuelled by biennials, large museums and galleries. Even art journals, which previously played a critical role, participate in this.[3]

3 See Laurens Dhaenens and Hilde Van Gelder in the introduction to Kunstkritiek: Standpunten rond de beeldende kunsten uit België en Nederland in een internationaal perspectief [Art criticism: Viewpoints on the visual arts from Belgium and the Netherlands in an international perspective] (Leuven: LannooCampus, 2010).

So where is there still a place in the art world for art as critical investigation and self-critique? Where can one find a locus, a platform for reflection and dialogue, which is not subject to pressures from the culture industry? Though universities are also being placed under increased pressure by a profit-driven mentality and cost-cutting operations, and though even here there is the looming danger of a cultural industry of 'knowledge production', academia nevertheless seems to represent a good candidate for providing the leeway for this.

Art and Knowledge

There is no simple answer to the question of whether research in art generates knowledge and the kind of knowledge that this may be. What do artists know?[4] Of course they know something about images; they know what it is to produce a 'picture'. Artists have a grasp of phenomena, how things appear to us in a visible guise — about this they know a great deal, but this is too general and therefore too non-committal. The assumption that artists know how things appear to us can only be demonstrated on the basis of specific works of art and this still leaves us with no answer to the broader question of *what artists know.*

In the context of research in art, perhaps it is better to pose a different question, namely how do artists think? Hannah Arendt's *Thinking*, the first volume of *The Life of the Mind*, might provide a way forward here.[5]

In *Thinking*, Arendt elaborates upon the distinction made by Immanuel Kant between two modes of thinking, *Vernunft* and *Verstand*. Arendt defines *Vernunft* as 'reason' and *Verstand* as 'intellect'.

According to Arendt, the distinction between reason and intellect coincides with the distinction between *meaning* and *knowledge*. 'Reason' and 'intellect' serve different purposes, she writes. The first manner of thinking, reason, serves to 'quench our thirst for meaning', while the second, intellect, serves 'to meet our need for knowledge and cognition' (the capacity to learn something). For knowledge we apply criteria of certainty and proof, it is the kind of 'knowing' that presupposes *truth*, in the sense of correctness.

'Reason' has its origins in our need to ponder questions to which we know there is no answer and for which no verifiable knowledge is possible, such as questions about God, freedom and immortality. Reason therefore transcends the limitations of knowledge, namely the criteria of certainty and proof. 'The need of reason is not inspired by the quest for truth but by the quest for meaning', writes Arendt. 'And meaning and truth are not the same.'

In the other manner of thinking, cognisance or knowledge, the thinking is a means to an end and that objective is the determination or attainment of truth

4 The question 'What do artists know?' was the theme of a round-table discussion on art and education, organised by James Elkins in 2010.
5 Hannah Arendt (1978), Life of the Mind, ed. Mary McCarthy, 2 vols. (New York: Harcourt Brace Jovanovich). Thinking was originally published in 1971.

and scholarly insight. *Verstand* wants to understand perceptible reality and operates by applying laws and fixed criteria to phenomena as they are perceived by the senses. *Verstand* is based on common sense, on faith in reality, in the 'authenticity' of the world. The scholar approaches the world with the goal of unmasking sensory illusions and correcting errors in scholarly investigation.

Reason, by contrast, has a self-contained objective; it is the pure activity of thinking and the simultaneous *awareness* of this activity while we are thinking. Reason is therefore not merely reflexive but also self-reflexive. The awareness of the activity of thinking itself creates, according to Arendt, a sensation of vitality, of being alive. Reason is the unceasing quest for meaning, a quest that never ends because of constant doubt, and because such thinking is ultimately founded on doubt it possesses what Arendt calls a 'self-destructive tendency with regard to its own results'.

In order to experience the thinking ourselves, in order to know the possibilities of one's own mind, it is necessary for us to withdraw from the 'real' world. Sensory experience distracts us when we try to concentrate and think, which is why we say that someone who is thinking concentratedly is 'absent'. To be able to understand the spectacle of the world from within we must break free from sensory perception and from the flux of daily life.

The scientist can also temporarily withdraw from the world of phenomena, but he does that to

10

solve a problem and with the aim of returning to that world and applying the answer there, to deploy the solution in that sensory domain.

Reason, writes Arendt, is 'out of order' with the world. It is a type of thinking that does not chime with the world and that is for two reasons: because of the withdrawal from the world that it requires *and* because it does not produce any definitive end result, it offers no solutions.

It should be obvious that it is primarily reason, *Vernunft*, which is the faculty of thinking that is relevant to art. Reason is the kind of thinking that is stored away in the work of art. Arendt therefore calls a work of art a 'thought-thing', and states that art 'quenches our thirst for meaning'. Art provides no solutions and has no objective beyond itself.

But what about the fact that the activity of thinking (of 'reasoning') presupposes invisibility, that it withdraws from the sensory world and turns inward to a place the outsider cannot see, while works of art are objects that are in fact *real*, palpable and visible, objects which are part and parcel of reality?

The work of art's 'reality' is idiosyncratic and diverges from other objects in the world — even in the case of ready-mades or conceptual actions intended to traverse the boundary between art and life. It is the function of works of art to generate meaning or to give direction to the quest for meaning. The work of art is the materialisation of thinking; thinking is

rendered visible in the work of art. In the work of art, that which is actually absent (the invisible 'reason', reasoning) is made present. Art questions all the certitudes that are accepted as matter-of-course, even those of and about itself.

The work of art is not the end product of the artist's thinking, or just for a moment at best; it is an intermediate stage, a temporary halting of a never-ending thought process. As soon as the artist has allowed the work as object out into the world, he takes leave of it. His activity with regard to this specific work now belongs to the past, and at this point the beholder, the public, becomes involved in the work. The beholder picks up the train of thought as it is embodied in the work of art.

The verb 'to know' implies knowledge, evidence, and is therefore not applicable to art or to what artists do. 'Knowing' harks back to concepts and criteria that belong in the world of exact science and with a mode of thinking that, in essence, is alien to art.

I would not want to aver that there is an unbridgeable gap between scientists and artists. Scientists have important intuitive moments, flashes of insight, when suddenly and seemingly out of nowhere the long-sought solution to a problem presents itself. Conversely, artists carry out research and their research is, at least in part, rationalisable and disseminable. However, the orientation of these activities and the way in which the thinking takes shape differs for scientists and artists.

The Book's Structure

This volume presents many different and sometimes contradictory viewpoints. The nature of the texts is also highly diverse, ranging from polemical and analytical to performative contributions.

However diverse the standpoints may be, all the authors engage in one way or another with art-as-research. A number of them are conducting their own research in the context of attaining a PhD. Some regard their way of working as a form of research anyway and see no need to do this within an academic framework. Others collaborate closely with artists as exhibition curators or are active in art education and supervise students at BA and MA levels. The theorists featured in this collection are all intensively involved with research in art, in their roles as supervisors of research projects, as professors or lecturers.

Some of the authors are highly critical of research in art. They are concerned about the consequences of the reorganisation of education for the arts and point to the perils of the institutionalisation and academicisation of the *modi operandi* of artists. They think that research in art can just as easily become a commodity of free-market thinking and commercialisation as the art product. Others regard *artistic research* to be an effective instrument to develop their practice further.

The texts by four authors, namely Kitty Zijlmans, Henri Jacobs, Stephan Dillemuth and Graeme Sullivan, are reworked versions of the keynote

lectures they gave at my invitation during the two-day 'The Artist as Researcher' symposium, which was held in February 2009 at the Royal Academy of Art (KABK) in The Hague. The visual contributions are a demonstration of research *through* images, making manifest what research in art can involve.

All the contributors, with the exception of Dillemuth and Sullivan, live and work in the Netherlands or Belgium. This demarcation is in a certain sense arbitrary, given that the subject of the volume extends much further than these small countries on the North Sea coast and the majority of authors are internationally active. It would, however, be impossible without delineation, and this collection therefore simultaneously presents a overview of research in art in the Netherlands. Yet much more than providing a state of affairs, it is the intention that, with its varied and occasionally polemical stances, this volume will make a major contribution to the debate about research in art and propel this discussion forward.

15

The Use and Abuse of Research for Art and Vice Versa

Jeremiah Day

In considering possible new roles for the artist as researcher, I'm reminded of a line by Clement Greenberg:

> Pollock's paintings live or die in the same context as Rembrandt's or Titian's... or Manet's or Rubens's or Michelangelo's paintings. There's no interruption, there's no mutation here. Pollock asked to be tested by the same eye that could see how good Raphael was when he was good...

Are works of 'artistic research' to be tested by a different eye?[1]

The new field of 'artistic research' hinges paradoxically on the question of function.

On the one hand, many regard the emphasis on research and the critical discourse surrounding it as a possible defense of art practice against the widespread instrumentalization of culture. When both the terms of the market-place (production of spectacle and of collectibles, justified through economics) or the public sphere (justified through supposed contributions to the 'greater good') threaten to overwhelm the cultural realm, the idea of 'pure research' holds the appeal of a possible oasis.

On the other hand, the focus on re-

search could itself be a way of bringing cultural practice more in line with current public policy focus on 'creative industry' and the 'knowledge economy', thus paving the way for an even more radical instrumentalization.

And at this point we have had much discussion but little demonstration, many good symposiums but few good exhibitions, thus risking that the whole thing could become another department of academia. Increasingly, discussions around 'artistic research' have the humorless and ahistorical tone of the social sciences.

'Academicism', in the early period of modern art, came to mean an inward and self-justifying irrelevance, and was rejected by Courbet and others in favor of an engagement in public life and conditions. This is the earlier and perhaps root paradox of function: the space within which to work for an engagement with the world was established through a rejection of applied art. One need only think of Joseph Beuys barking like a dog at the microphone during an academic ceremony to feel the

1 The term is problematic inasmuch as it seems to qualify a kind of research as 'artistic', as opposed to qualifying a kind of art that might be research-ic. To make matters worse, 'artistic' does not generally mean 'of the arts' but rather embellishment or holding a decorative quality. Something like Ed Sander's phrase 'investigatory poetics' would be more appropriate. (Thanks to Fred Dewey for pointing out this important precedent.)

virulent rejection of the role of the functionary. And Beuys and his peers articulated an understanding of philosophy, history and politics as artists and through artworks – i.e., the exact space 'artistic research' aspires to inhabit.

The emphasis on subject matter and on experimental methods and the insistence on a dialogue between one's own art-making and the questions of art-in-general are part of modern art. 'Artistic research' then could be established as a formalization and concretization of what already exists in an under-defined way: visual art as a highly intellectual field with its own questions and claims.

'Artistic research' must be judged by the same terms as art in general. If we disconnect from the traditions and capacities established in the last hundred years, we will throw out the baby with the bathwater, and cut off the legs upon which we stand. The risk is not just instrumentalizing art, but abolishing it altogether in favor of some new form of design. The new field would turn out not to be an oasis, but only a mirage.

21

Art Research

Hilde Van Gelder

Writing an essay about what it has meant to me to be involved with practice-based research, in particular with supervising PhDs in the Arts, implies adding autobiographical detail. My initial experience in this field occurred in 2003—04 when at the University of Leuven in the Arts. I was the supervisor of the first PhD in the Visual Arts completed in Belgium, *The Experience of Time in Still Photographic Images* by Maarten Vanvolsem, in 2006.

I had already gained some experience in this burgeoning field of academic research as a visiting scholar at New York University's Department of Art and Art Professions, in 1997—98. With influential teachers such as Peter Campus and RoseLee Goldberg, the department's staff was highly involved in developing both research-based artistic activities and advanced collaborations between theoreticians and practitioners, encouraging both sides to move away from the established divisive paths and to cross-fertilize one another's disciplines.

The field has expanded greatly since the turn of the millennium. A great deal has already been written about the implications of research-based activities for the way both visual artistic practice and artistic output in general are conceived.[1] Much less, however, has been said about what this development has meant for the established discipline with which research-based visual artistic practice now has a completely new relationship: art history.

My reflections on what research practices mean

24

for visual art today arise from the changes I have been able to discern in it, as well as a concrete example from my own practice. The argument will arrive at conclusions for research in the field of art today and tomorrow, a discipline I wish to define as a new, crossover form of art research.

The Future of Art and Art History: Research with Art

One of the main results of my involvement in supervising practice-based research in the visual arts and long-term collaborations with many visual artists such as, most prominently, Allan Sekula and Philippe Van Snick brought a strong urge to reflect on what it means for art history and how it allows us to project the discipline into the future.

Under the influence of dominant models from North America over the past forty years for theoretical research into contemporary art, art history has been obliged to move beyond traditional, detached connoisseurship. Seizing advantage from interdisciplinary approaches or adopting new methodologies from fields like semiotics, psychoanalysis, Marxism or feminism, it has actively opened its horizon towards a contextual understanding of artworks and an

1 For the articulation of my ideas on the topic, I refer to Jan Baetens and Hilde Van Gelder, 'The Future of the Doctorate in the Arts', in The New PhD in Studio Art, ed. James Elkins (Washington: New Academia Publishing, 2009), pp. 97-110; and to Hilde Van Gelder, contribution on various pages to transcript of the 3d Stone Summer Theory Institute (2009), in James Elkins and Frances Whitehead, eds., What Do Artists Know?, vol. 3 of The Stone Theory Seminars (University Park, PA: Penn State Press, 2012) [in print].

engaged, participatory spectatorship. Art history has proven its aptness as a rapidly transforming discipline of research into contemporary art.

But it has encountered difficulties. Adopting methodologies from other research domains has, in certain parts of Europe, led to a change of name: from art history to *Kunstwissenschaft* in Germany or in Flanders to *kunstwetenschap/kunstwetenschappen* — both the singular and the plural form of the term are in circulation. While art history has also had to define itself in relation to the now firmly established field of cultural studies, it has arguably had fewer difficulties in distinguishing itself from the once fashionable field of visual studies, now in rapid decline.

In the wake of these disciplinary transformations, contemporary art historians have intensified their interactions, collaborating amongst themselves as well as with art practitioners. Trans-disciplinary research approaches influence each other, resulting in newly conceived visual and textual materializations of ideas. Through their collective work theoreticians have reached a better understanding of the topic, often allowing them to add multidisciplinary insights.

Today, some art theoreticians and researchers in other fields of the humanities, and even sometimes in the sciences, go as far as overstepping the boundary and feeding their own work with the empirical methodologies of art practice, deepening their arguments through illustrations of visual work they made themselves or that was made by close collaborators.

26

Practitioners now frequently complement their artworks with texts they have written themselves or with passages taken from theoretical works, often chosen in close collaboration with a theoretician.

Case study: Photography and Time

Maarten Vanvolsem, who initially started his PhD research at Newcastle University, is now working as a photography teacher in Sint-Lukas Brussels University College of Art and Design. His elongated horizontal prints of large sections of photo film, even entire films have gained him a solid international reputation. He produces these images by means of a self-built camera in which a film moves before an open shutter at the speed determined by the artist turning a manual handle. He has more recently been experimenting with a handheld digital camera.

Fundamental to the making of these works is that their shooting involves time: it takes much longer than just a split-second pressing of a button to produce them. The spectator's perception of these works operates on various levels of temporality. One can attempt visually to take them in all at once, but that is a confusing operation. The images seem to be somehow unfolding themselves internally, hampering immediate comprehension. Only a carefully extended temporal apprehension allows a full understanding of the fact that the images offer a distorted impression of a particular space, landscape or person.

While the earliest nineteenth-century photo-

graphs were reputedly slow to make — a daguerreo-
type took about fifteen to thirty minutes — William
Henry Fox Talbot was able to reduce the exposure
time for paper negatives to one second in the early
1850s, leading to the general opinion that photo-
graphy is an instantaneous medium.[2] Vanvolsem's im-
ages put into perspective the dominant, modernist
logic of seeing a photograph as a snapshot that dem-
onstrates how the photographer's pushing of the but-
ton immobilizes a decisive moment in time — under-
stood as the photographic freezing of a fraction of a
second. There is no instantaneous automatism in his
work. Duration becomes an integral element of the
whole production process. It took him, as the photog-
rapher, more than a split-second to make the image:
the final result thus reflects a temporal extension of
the artist's own lived time.

Maarten Vanvolsem's theorizing of this funda-
mental aspect of his photographic practice required
recourse to art history and art theory. This was the
moment when our research relationship as super-
visor and doctoral student developed into a fruitful
exchange of expertise. In my doctoral dissertation in
art history (Leuven, 2000), entitled *Temporality and
the Experience of Time in Art of the 1960s*, I interpreted
late-1960s and early-1970s post-minimalist, material
art practices by for example Robert Morris, Hans
Haacke, Eva Hesse, Bruce Nauman, Michael Snow
and Dan Graham as reflecting what Robert Smithson
calls 'the time of the artist'.[3] In that conception, the

work of art '*contains* its making time. It is a trace of its making process, or an *index* of its own production.'[4]

An understanding of the artwork as a 'container of amassed time', as I put it (2004: 85), became of crucial importance to Vanvolsem's comprehension of what is at stake in his own work. Previous ideas of the artwork bearing witness to its making time and thus possessing an inherent temporal dynamic had been expressed by Etienne Souriau's concept of the 'intrinsic time' of an artwork.[5] Building on this concept, my dissertation presented a hypothesis of the intrinsic time of the artwork as containing the time of the artist. It both determines and steers the spectator's temporal/durational perception and understanding of the artwork.

In his dissertation chapter on the perceptual reading of his strip technique photographic images, Vanvolsem explains how crucial his notion of the intrinsic time of the work of art has been to coming to terms with what is at stake in his own photographs. He argues that, with their distortions of landscapes, changes from sharp to blurred and fleeting vanishing

2 For a more detailed exposé of this development, see Hilde Van Gelder and Helen Westgeest, Photography Theory in Historical Perspective: Case Studies from Contemporary Art (Malden: Blackwell, 2011), pp. 74-76 and 85-88.

3 Robert Smithson, 'A Sedimentation of the Mind: Earth Projects', in Robert Smithson: The Collected Writings, ed. Jack Flam (Berkeley and Los Angeles: University of California Press, 1996), p. 112. First published in Artforum, VII, 1 (September 1968), pp. 44-50.

4 Hilde Van Gelder, Temporality and the Experience of Time in Art of the 1960s, PhD thesis (Leuven: KULeuven, 2000), p. 208; see also my 'The Fall from Grace: Late Minimalism's Conception of the Intrinsic Time of the Artwork-as-Matter', Interval(le)s–I, 1 Fall 2004, p. 94. http://www.ulg.ac.be/cipa/pdf/van%20gelder.pdf.

5 Etienne Souriau, 'Time in the Plastic Arts', The Journal of Aesthetics and Art Criticism, VII, 4 (June 1949), pp. 294-307; see Hilde Van Gelder and Hans Vlieghe, Temporality and the Experience of Time in Art of the 1960s (Leuven: n.p., 2000), pp. 21-25.

point, repetition of depicted objects, and size, his strip photographs disrupt all that might possibly be left of the basic consensus that a photograph is a true representation of the world. The strip photograph comes out as alienated from reality, as the depicted space is only vaguely reminiscent of what the real world original looks like.[6]

Such alienation pushes the viewer to a closer and longer inspection of the image than would be usual for a snapshot. What then becomes visible to the viewer is the 'displacement of the photographer during the making of the image',[7] Vanvolsem writes. As an active participant, the viewer thus has to remake the image before understanding what is depicted in it. He concludes:

This remaking of the movement in space translated itself in an experience of time. It is the exploration of the image, its surface, its process that leads to the photographer as maker of the image, and evokes the active experience of looking.[8]

While an exchange with my earlier research on the topic of time and the image appeared central to Vanvolsem's doctoral research, his findings in their turn have profoundly influenced the ideas that Helen Westgeest and I develop in a chapter from our forthcoming book, *Photography Theory in Historical Perspec-*

30

tive. We build upon Vanvolsem's argument and suggest that his images can be understood as engaging in a multiplication of temporal viewing processes, as the differences in sharpness along the image generate different reading speeds:

> Each change from sharp to blur, or, vice versa, from blur to sharp, will cause the movements of the spectator's eyes to accelerate or decelerate.[9]

To sum up this case study, Maarten Vanvolsem's research and that of Helen Westgeest and myself have substantially benefited from our longstanding, close interaction over the years. Most probably, neither of us would have reached any of these conclusions if we had proceeded with our research independently from one another. We have mutually progressed in an inestimable way, to the benefit of research in the domain of art in general.

Art Research: A Definition

In her introductory statement to this book, Janneke Wesseling, speaks of an 'artistic turn in academic education.' She argues that both the rapprochement of art

6 Maarten Vanvolsem, The Experience of Time in Still Photographic Images, PhD thesis (Leuven: KULeuven, 2006), p. 201. The passage is included in Vanvolsem's forthcoming book, entitled The Art of Strip Photography: Making Still Images with a Moving Camera (Leuven: University Press Leuven, 2011).
7 Vanvolsem, op. cit. (note 6), p. 201.
8 Ibidem.
9 Vanvolsem, op. cit. (note 6), p. 84.

and science and a shift in their mutual positions have been set in motion by artists and by changing notions about scientific research in the academic world.[10]

This rapprochement has prompted researchers in the wider field of art to ask critical questions about our conceptions of the idea of knowledge.[11] Convinced that they can provide an inspiring tool for widening the prevailing scientific and academic frameworks, they also claim that the opening of the field of artistic discourse, reflection and production into a domain where, for centuries, it did not naturally belong — the university as distinct from the academy — offers artists new instruments for making statements about the reality surrounding us.

With Janneke Wesseling, it can be argued that developing academic research in this expanded field of art is of crucial importance. As the art world and art production are now firmly in the grip of the globally capitalized market, several artists are actively looking for new creative environments where they can operate, at least to a certain extent, more freely.

Art research, as this new type of research is now increasingly defined,[12] can provide an engaged alternative to commercially embedded art. Situated in the joint collaborations between universities and art colleges, art research is crucial to offering a new way to anchor art in today's society, and giving it the critical cultural voice that our society needs.

At the intersections of theory and practice, constantly developing its research processes, methods and

forms of output, art research is a promising new discipline with a substantial potential impact on other disciplines. It allows for a more distanced meta-reflection on topics that are the subject of fundamental research in other domains. Its impact is realized through a complex combination of words and images that creates an indirect reflexive effect radically different from any reflection seen within a specific discipline.

For example, looking for new theories of global justice today might imply moving beyond law as a well-defined set of rules and methods. As art research is relatively detached from the methodologies or discourses of these long-established disciplines, it has the potential to open up new perspectives for the researched topic, thus aligning itself with Agnes Heller's claim that the goal of justice is beyond justice.[13] Understanding how contemporary global justice can be conceived of might imply a move beyond established theories of justice, often still very much embedded in the now increasingly failing model of the nation state and its citizens.

Any call for justice today should be, as Heller argues again, a call for a better life for some, yet it is based on a moral duty for all and it might demand

10 See also my 'A Pendulum Motion between Art and Science: Jeffrey Wyckoff's Mastery of Excess', in Fusion: Art and Science, ed. Victor Faccinto (Winston-Salem, NC: Wake Forest University Art Gallery, 1999), pp. 18-19.
11 This is expanded in Hilde Van Gelder and Jan Baetens, 'On the Body as the Subject of Experience: Art as a Necessary Element of the Genesis of Knowledge', Image [&] Narrative, 9 (October 2004). Available at: www.imageandnarrative.be/inarchive/performance/vangelder.htm.
12 See www.workshop.ciac.pt/.
13 Agnes Heller, Beyond Justice (Oxford: Basil Blackwell, 1987), p. 326. The following quotations are on p. 327.

efforts from those who now already enjoy a good life. Potentially, art research, while engaging in this discussion on a visio-textual level, offers a different perspective on it and can therefore impact on the collective understanding of those topics, proposing solutions and advancing reflection within the research discipline with which art research engages, allowing that discipline to move beyond its own state of the art.

Art Research: A Proposal for Sustainable Output

In line with a growing call for reducing the ecological footprint of visual artworks, exhibitions and art historical/art critical research output,[14] art research has the potential to go against the grain of what now is called the art world's 'extraordinary environmental profligacy',[15] meaning that artworks travel all over the world, paying no heed to their ecological footprint. This is an increasingly urgent situation, since it is ecologically untenable.

Proposing sustainable solutions is a task for which the academic environment is well equipped. The university, as a democratically critical space for free reflection, collective dialogue and intellectual production, is able to operate independently of the art market's concern for preserving the image's market value, by limiting its editions, by retaining the image's display and circulation in hands of experts who use copyright legislation with a commercial bias.

Sustainable forms of output are valid for art

practitioners and art historians/theoreticians who want to amplify their publication possibilities. Furthermore, the university is a place where they can join forces, find one another and realize collective work.

— There is the option of the video essay.[16] Critically engaged films can circulate as DVDs with a relatively low environmental impact across great distances. It is today a field in which art practitioners and theoreticians often collaborate.[17]

— More comparative research needs to be done into the sustainability of e-editions compared to the paper versions of books. Art practitioners and theoreticians can join hands here, and propose solutions that are as durable as is feasible in the current situation.

— Most certainly books and websites/weblogs can increasingly come to function as the most durable of all virtual exhibition spaces of art research output.[18] The further advantage of the weblog is that the public can be encour-

14 T.J. Demos, 'The Politics of Sustainability: Art and Ecology', in Radical Nature: Art and Architecture for a Changing Planet 1969-2009, Francesco Manacorda, T.J. Demos (London: Barbican Art Gallery, 2009), pp. 16-30.

15 Julian Stallabrass, 'Museum Photography and Museum Prose', New Left Review, 65 (September-October 2010), p. 120.

16 Ursula Biemann, 'The Video Essay in the Digital Age', in Stuff It: The Video Essay in the Digital Age, ed. Ursula Biemann (Zurich: Institute for Theory of Art and Design, 2003), pp. 8-11.

17 For example, I figured among the research advisors for the 2010 Venice Film Biennale award-winning The Forgotten Space (2010), directed by Allan Sekula and Noël Burch.

18 An example of this approach is a book-length study of Belgian artist Philippe Van Snick's work that I co-edited: Philippe Van Snick: Dynamic Project, eds. Liesbeth Decan and Hilde Van Gelder (Brussels: ASA Publishers, 2010) [352 p.]. This book is a virtual retrospective exhibition of Van Snick's work.

aged to add works to the show, and thus to co-curate the exhibition.

A Framework for Art Research

Within the humanities a debate is now raging about how to set the rules and criteria, as well as finding the best methodology, to rightly and righteously assess research within artistic areas.[19] What was formerly known as research on and in the arts — the 'on' indicating theoretical approaches and the 'in' the practice-based methods — are increasingly becoming intertwined.

While there is a general consensus that the creation of an appropriate academic environment able to match the specific needs of research operating in the in-between space of art theory and art practice is overdue, there is much less agreement about the embedding of such research within existing university and art college structures. Should art colleges affirm their independence from universities while developing a research culture or should they instead merge with particular university departments? If so, with which departments? Can art history departments hold a privileged position or should they be kept at bay as much as possible?

Given art history's proven chameleonic potential, it is my claim that art history can be crucial in determining future influential sites from which to speak about contemporary art. While the genesis of innovative forms of research in contemporary art is already underway within several of these departments,

art history's long established tradition can contribute to the invention of a vocabulary. The now-dominant misunderstanding that these new research forms in the field of contemporary art are only there to overthrow already existing, established disciplinary categories needs to be countered.

They in fact aspire to offer something fundamentally new that does not propose to supplant either art history or art production as we traditionally think of it. Rather it places them in a shifting, contemporary perspective that opens up new horizons and unseen opportunities for innovative, team-based research within the humanities, a sector more traditionally based on the model of the solitary researcher than the other sciences. The new interactions and collaborations tend to give that plural noun of the humanities a double inflection. They propose to engage multiple disciplines within the humanities, also promising to critically question the very concept of humanity and to commit themselves to the multiple humanities of the future.

As a new paradigm is in the making, there is a strong need for consensus about the consolidation of valid research standards, both for art practice and art history/theory. For example, profound knowledge of the art of the past is an invaluable tool for understanding the art of the present. Yet, studying the art of the past cannot be compared with the study of the art of the present. Contemporary art is not a dead business;

19 See, again, www.workshop.ciac.pt/.

the subject of study, the artist who made the objects, is most probably still alive. Advanced research in contemporary art history involves finding ways of working with the artist in an approach that distinguishes research in the field of contemporary art from other art-historical research. It does not fit neatly into our usual perspective on the discipline.

Given its relative lack of secondary information sources and its being based on discussions with the artist, the resultant writing is commonly art-critical or art-theoretical rather than art-historical. From an art historical perspective, the writing is often seen as less conventional and more experimental, making greater use of interdisciplinary approaches. Today, when historians of contemporary art are ready to conceive of new forms of research output, such as films or DVDs, which may closely resemble artistic output, the discipline finds itself under pressure. What is artistic and what is art historical output? And how can one define benchmarking criteria for the crossover, in-between discipline of art research?

Art research is a growing academic discipline, stemming from the collaborative synergy between art history (a traditionally accepted academic discipline) and art practice, a traditionally strongly anti-academic discipline. Within this field of paradoxes, a new field is created that aspires to negotiate this tension, constructively and positively. To further shape and define itself, art research will have to embark on a type of scholarship that draws from the methodological experience

38

of other disciplines, such as the social sciences.

Through interviews with key operational stake-holders art research can both gather information and raise awareness of the issues to be addressed in designing new models and tools. The effort of identifying shortcomings as well as opportunities in this respect will be greatly enhanced by having such insider testimonies. Do prejudices sometimes distort the lived experiences of the people concerned? Any deficiencies will have to be addressed if the objective of finding relevant criteria for art research is to be attained.

This is already absolutely necessary in the short term. For example, the Research Foundation-Flanders has decided to position research in art under the same commission as literature research (CULT 2), thus separating research in art from art history, which is referred to as the history commission (CULT 3). Although only recently established, this schism has manifested major disadvantages and risked even greater confusion.

The current pattern of hesitancy within the field of art research is unsatisfactory, particularly from the point of view of consistency in the training programs and of the need for legal certainty. I would therefore like to conclude with an open call on anyone who feels involved in this kind of research to contribute to the drafting of a new theoretical framework outlining the balance and interaction between minimal and optimal synergy, and between European art theory and art practice.

Shifting Shifting Sitting

Aernout Mik

LA LEGGE

Absinthe and Floating Tables

Frank Mandersloot

The air which one breathes in a
picture is not the same as the air one
breathes outside.
Edgar Degas

The first painting with which I became
acquainted as a child was a creditably
rendered copy of L'Absinthe, the famous
Degas canvas from 1876. My parents had
seen the original in Paris in 1949 and on
their return to Utrecht they asked a painter
friend to produce a scaled-down replica
based on a picture postcard. In my youth
the painting hung on the wall above the
piano at home and clashed with the mod-
ern interior with Pastoe furniture in a
house designed by Rietveld. For a long time
I hardly glanced at this painting, possibly
because it was hung high on the wall and
the sombre colours are unattractive to a
child and the scene incomprehensible. The
woman gazes vacuously into nothingness.
The man beside her looks away, to some-
where beyond the frame of the painting.
 My first witting contact with the paint-
ing was when I tried, aged about six, to
insert a pine branch with a shiny ball at-
tached to it behind the frame, causing the
matchbox that was clamped between the
wall and the painting to fall to the ground.

The painting suddenly hung flat against the wall, so that the varnish on the canvas began to shine as intensely as the Christmas bauble.

When I was about eight years old I used to pore over drawings with the caption 'Spot the missing thing', and then I also suddenly noticed that the tables in Degas' paintings have no legs. I still didn't understand what those two drinkers were doing there, but it did become clear to me that they existed in another world.

When I was about twelve years old I wondered whether there was a connection between the drunken absinthe drinkers who sit on invisible seats and floating tabletops, and that question has puzzled me ever since. The looking away, the staring, the not looking at the things, things that float: everything seems absent. The two people's directions of gaze and the diagonals of the tabletops are also a hint not to look directly at the painting yourself, but beyond it. The picture seems to be there only to emanate the alcohol-filled air and to overcome the beholder with a look which also alters everything outside it.

Artistic research is a state of mind in varying guises. Research can be pre-linguistic,

discursive or post-visual. The gaze can stray, the mind can muse and the thought can raise a question to which there is no answer. Such a question can lead to speculation with proposals in all possible forms and functions.

Our focus is usually directed at the cognisable, in which the looking is instrumental in the knowing and the becoming familiar. But with the outlook into which Degas initiated me, the question that counts is not what I am looking at but rather how what I am seeing affects me and what I then do with that condition myself. For artistic research it is important to forget (time and time again) and to digest 'data'. Because it is not the labelling of things that is interesting, as in and of themselves they mean nothing, but the experience of the relationship to things in passing; not by zooming in on them but by being in their midst and sliding past them. This not knowing is a drifting in that same world, not in another. That is also how Degas would have sat in the café. Absinthe can be absent.

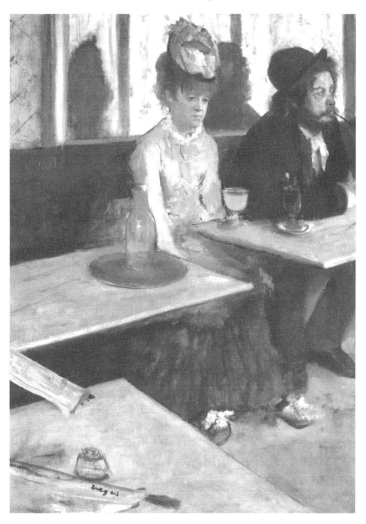

Edgar Degas, L'Absinthe, **1876**

The Chimera
of Method

Jeroen Boomgaard

Research in the arts is making great strides and seems to be heading towards a glittering future. Nevertheless there is still enough opposition from those who believe that art ought to maintain a healthy distance from the formalisation that is typical of the path to a doctorate, as well as from sceptics who think that artists have always carried out research, thus making a PhD is a meaningless endeavour. To a large extent these sceptics and objectors are correct: the combination of art and formal research is troublesome and perhaps even superfluous. It is therefore worth considering what is feasible and whether this involves a new manner of research that actually yields something meaningful.

The resistance to art as research often focuses on the question of the method. If artistic research wants to establish itself as a recognised discipline, then a clear-cut and distinctive method seems necessary. But if art really wants to remain art it can never surrender to a straitjacket that seems to constrict each and every basic principle, method of working and outcome *a priori*. In short, the method is the hallmark of true science , while its absence or avoidance, or indeed its subversion, is the hallmark of true art. This contradistinction is, however, overly simple. Though scholars rely on established methods to gain recognition for their findings, the methods they employ are never undisputed.

The primary concern of the theories of Popper, Kuhn and Feyerabend was the need to establish

a broadly recognised basis for research as well as the impossibility of fixing that basis for the longer term. While Popper wanted to provide science with a dependable basis with his 'principle of falsification' (i.e. a theory can only be regarded as truly proven when it is in principle possible to prove that it is incorrect), Kuhn demonstrated that scientific principles are constructs (paradigms) which stand until they are replaced by another outlook, often after a long and bitter struggle.

With his *Against Method*, Feyerabend believed that he could actually dispose of every form of overarching procedure. Feyerabend was somewhat overly optimistic about that, because every researcher is still expected to account for his or her working methods meticulously, even though the chosen method is seldom employed unquestioningly. Within a discipline there is often no question of a single, generally recognised method; usually there are several conflicting ways in which research can be conducted. On the basis of a difference of opinion in this sphere, academics within the selfsame discipline can whole-heartedly reject each other's research conclusions. So method has something to do with power as well: it is a manner of doing research but also a manner of speaking and/or writing that by definition structures the research and furnishes it with its power base. All the more reason, you would say, for art to resist this with might and main.

The only way in which art would be able to maintain its unconditional and a-methodical charac-

ter in a formal research environment must therefore lie in the very emphasis of this rejection of a fixed *modus operandi*. The artist chooses his or her own way of working or the artist's method calls into question all the other methods. Research in the arts would then primarily distinguish itself by employing a research method that is much more open, much more focused on questioning the method and its limiting aspects than is the case in existing disciplines. Such a critical stance is not, however, the exclusive preserve of the arts. Every branch of learning that takes itself seriously reflects on its own *modi operandi*. It is therefore a fundamental hallmark of any scholarship that on the one hand the method is employed as a guiding principle and a guarantee, while its implicit premises and the effects of embedding it in a framework are called into question on the other. That has been the basic assumption since the critical, neo-Marxist scholarship of the 1960s, and in most disciplines Foucault's analysis of the power of discourse has only reinforced that self-critical tendency. It has long been accepted that there is a critical tradition that inevitably leads to new dogmas, which will in turn be questioned and stretched by a new generation of cutting-edge research.

Research in art is in turn not as a-methodical as is sometimes suggested. Since the advent of conceptual art in the 1960s, more or less every work of art has been the product of rules that the artist personally formulates in order to subsequently carry them

through to their ultimate consequence. In that sense every artistic production follows a rigid method, and even a decision such as 'returning to landscape painting' inevitably falls into this category. Yet every artist determines that method for himself and the idiosyncratic character of the rules lends art the aura of freedom and arbitrariness. All these specific methods combined means that the method for the arts is general. Art is identified and acknowledged on the basis of the fact that the work of art is the result of a set of rules, a system of guiding principles and procedural precepts chosen by the artist that lead to 'something' being created — a painting, an installation, a process, a course of action, possibly even a discussion or a performance — a result that therefore manifests itself as a work of art. Though the method often remains undefined and the rules are rarely formulated explicitly, it is a system that is peremptorily present *a priori* and is the basis for schools and movements which can be as at odds with each other as the various methods in the sciences. For no matter how idiosyncratically the rules are formulated, groups or systems of kinship and exclusion emerge. The country's various MA courses turn out different kinds of students who base their practice on highly diverse forms of rule-making. For example, while one academy prioritises a theoretical basis, another proceeds more from traditional forms of artistic practice. The disciplines in the arts are therefore shaped by these often implicit systems, or combinations thereof, rather than by the time-

honoured division into painting, photography, video art and so on. However, this does not mean that this system can automatically form the basis for artistic research: this is the method for the creation and acceptance of art; for artistic research more is needed. In exactly the same way scientific disciplines renew themselves by critically examining the tenets of their own research, research in the arts that takes itself seriously will have to reflect on these regulatory systems.

So what are the implications of this situation for artistic research? How can an artist who wishes to gain a PhD deal with a scholarly approach that in one breath calls itself into question and in the next breath advocates a compulsory but individually customisable system of rules as a means of production for art? How can artistic research derive its own methodology from this? Like all nascent disciplines, artistic research will for the time being primarily borrow its procedures from other disciplines. To make it patently clear that research is involved, this form of research will often fall back on the disciplines which have long been associated with certain artistic disciplines (art history, theatre studies, musicology), but it will more often make use of branches of learning which have a more umbrella-like character, such as philosophy and cultural studies. But actually all branches of learning are at its disposal, because no single field has been demarcated on which the research must focus.

As the name already suggests, artistic research

is primarily characterised by its specific angle of approach and not by the presence of a field framed specifically by discipline within which the research is conducted. Artistic research can encompass everything, because it employs a method that differs from that in other fields of scholarship. The question of the method, which is often timorously avoided in discussions about research in the arts, is in fact axiomatic. And the crux of that as yet undefined or indefinable method is that very conjunction of scientific methodology and the rules of art as outlined above. The outcome of artistic research can therefore only be a result that has been achieved using this specific method and it can be judged only on that basis. Artistic research renders something visible, or furnishes an insight or knowledge that another form of research cannot accomplish, and that 'something' resides in the fact that art plays a pivotal role in the research.

This may sound self-evident, but it raises issues that go to the very core of the *modi operandi* of artistic research, in asking how a method of research focused on dissemination can be combined with the non-discursive power of the work of art. How can research in the arts meet the need for formulation and generalisation that scholarship requires of it while at the same time carrying out research through works of art that systematically want to avoid a general formulation?

The question is also therefore important because it touches directly on the role that a text, an account or a report fulfils in this form of research.

The question of whether or not the method of artistic research and especially how it is reported requires a textual component sparks heated debate, but questions about the role of text are broached all too rarely. While objectors are of the opinion that writing a research report overly compels artists to step outside their usual territory, its proponents see it as the only possible means of ensuring that artistic research counts as true research.

Yet there is still something remarkable afoot when it comes to the relationship between the method and the written research report. Apart from a few exact sciences in which the formulation coincides with the research itself, there is in effect a two-fold requirement or expectation. The mode of research — asking questions in order to find answers — is complemented by a working method which prescribes how the research — the questions and the answers, the process and the outcome — is written up and disseminated. This notation ensures that the research gains recognition, and not simply because the correct procedure has been followed but also because it has been written up in the correct manner. The way in which the research must or can be communicated thus determines to a large extent how it is conducted, which questions are asked and which are ignored, how detailed it must be, or the breadth of perspective that is expected.

As yet, this conclusion does not seem to have prompted much reaction within the praxis of artistic research. It nevertheless has far-reaching consequenc-

es for the textual component. When artistic research is chiefly defined as an investigation in and through the arts and when the textual component is also regarded as a justification of the research — a description of what was done as well as an appraisal in the light of existing studies or other art projects — then that textual notation functions as a precept that structures the research in advance. It is a text that is drafted in retrospect, yet it is compellingly present from the very start. And so the problem for many artists is not that they do not know how they must package their research according to this formula, but rather the fact that their research proves to be incapable of escaping this formulation during the process, so the text is no longer an elucidation of the work but the work of art inevitably follows that text, albeit contrary to the will of the researcher.

Would it not therefore be appropriate to choose to omit such a text altogether? The research then takes place in and through the work; the work of art is itself the reporting mechanism. The question, however, is how exactly it would then establish itself as research in the public domain. How can it be discussed, received and evaluated as research? How is it different to other process-oriented, open-ended works of art, which may indeed investigate something but do not want to be recognised as research?

To return to what is set out above, how can the rules for creating art be distinguished from a method of research? A confusion of these two systems is

evident in works that display forms of research while remaining within the artistic domain. Hallmarks of research, such as text, diagrams, statistics, documents and reports, then form part and parcel of the work of art. Although these works involve an attempt to save the work of art from its solipsistic perspective and its isolation, in my opinion it is sooner an instance of the 'rhetoric of research'. The work wants to be visible as a form of research, but primarily to be seen and discussed as a form of art. It thus becomes part of a recently formulated system of rules in which methods and forms of research are deployed in a more or less indiscriminate manner to create art. In relation to the text this is the converse of what was described: the research serves as an illustration of the work of art but any coherent statement is unforthcoming.

The work of students following the MA in Artistic Research at the University of Amsterdam (UvA) provides an example of the way in which you can try to avoid these two pitfalls and maintain a balance between the two aspects — science and art — that together form the core of the artistic research. The students following this MA, which is open to creators from the worlds of dance, music, theatre and the visual arts, are from the very start primarily interested in the questions and problems that are intrinsic to fundamental aspects of their respective disciplines. While the visual arts students are keen to explore notions of representation and visibility, for the students

from the worlds of theatre and dance it is more about performativity and embodiment, while for the musicians representation plays no part whatsoever and their focus is on temporality and displacement. This means that the methods they choose for their research are directly linked to this presentation of a question, being the ways of working that best allow them to answer the questions their artistic discipline raises. The students therefore generally 'borrow' their research methodology from the discipline which concerns itself with the art that they produce, as well as from disciplines which enable them to reflect upon their practice at a more philosophical or theoretical level.

The only 'method' in which the students of the MA in Artistic Research are trained is the combination of scholarship and art that is typical of artistic research. That is why they on the one hand acquire knowledge of existing research methods and are trained to write texts which can be discussed and accepted as accounts of research within the humanities, while on the other hand their artistic practice is stimulated and evaluated as a system of personally formulated rules. The two aspects of their research are thereby set within a clear-cut framework. On the one hand there is the research within the existing traditions of the humanities and on the other there is the framework of existing forms of art production. They must establish a link between these two aspects in their personal research. Formulating a research question which can be investigated with the aid of existing

scholarly disciplines as well as by means of their own artistic production is a way of preventing one of the two approaches predominating. In order to clarify why the whole is indeed greater than the sum of the parts and what the added value of artistic research can represent, I will outline a couple of graduation projects.

Maartje Fliervoet completed her MA in 2010 with the *Zero Panorama* project, which consisted of an exhibition at the Dutch Foundation for Art and Public Space (Stichting Kunst en Openbare Ruimte, or SKOR), several posters that were distributed in the venue's vicinity, and a text bearing the title *Nulstructuren. Het onbepaalde in het werk van Robert Smithson* (Zero structures. The non-specific in the work of Robert Smithson). The whole project formed a reflection on several texts and projects from the 1960s and '70s by the American artist Robert Smithson, texts in which he had called into question the effect of exhibition spaces. However, in a certain sense the graduation project also constituted a reflection on artistic research itself. The thesis clarified the theory about the non-specificity of spaces to which Smithson subscribed, but in an installation it simultaneously demonstrated that such explanatory texts must leave a lot unsaid. The danger of such an investigation is that it is over-ambitious and that some of the tacit intentions fail to live up to their promise. But perhaps that emphatically incomplete, that non-solution-focused, is a crucial quality of research in the arts.

More complex still is the shift that Johannes

Westendorp's project set in motion. He created a music installation with the title *Inside Mount Lu* for his final project, for which he collaboratively developed eight objects that most closely resemble the walkers in which toddlers learn to take their first steps. Participants in the project had to install themselves in these walking frames, surrounded by electronics, with something resembling an upturned bucket above their heads and frosted goggles before their eyes. When the participants started to move around the units produced sound, the loudness and pitch modified by the distance from other units. Westendorp's accompanying thesis does not address this complex installation but examines the notions of 'territory' and 'transposition' under the title 'Verplaatsingen' (Transpositions), exploring these notions in five essays. One essay is a philosophical reflection, another is a text that strikes one as literary, but the most important part of the thesis is an analysis of the work of the composer Brian Ferneyhough. In this project, too, the artistic research itself takes centre stage, but Westendorp is more emphatic than Fliervoet in wanting to demonstrate that the transition from one field of experience to another is impossible. You reflect on transposition, you read a literary text, you follow the analysis of a composition or you experience a piece of music by being part of it. All these elements are brought together as different forms of experience and, by extension, as just as many irreconcilable outcomes of the research.

69

In the model I propose here, the different knowledge systems continue to exist alongside one another. The basic premise is that the academic research and research through art can complement or even comment on each other, but they cannot converge. Scholarly research is always reflexive and draws conclusions; it always reports on 'something' that is itself not present in the account, and no matter how self-critical the methodology may be, the text of the research almost always reads like a final destination.

Researchers in the field of artistic research have a double-edged-problem: they not only investigate an 'object', but they also investigate with the aid of the 'object'. In addition, they first of all investigate with the means that their artistic discipline makes available to them. The research is pursued with the aid of photography, with the body or with a musical instrument, and thus takes the form of an image, a choreography or a piece of music. However, a work of art is never conclusive. The work of art presents itself as a straight fact, as a given, and in that sense you might term it affirmative, but it is at the same time it is always open in character: the path that the work has taken is not yet fully travelled, and the beholders must pursue that path further for themselves.

This open-ended quality of art leads to the stock remark that the work of art 'provides no answers but poses questions'. That formulation does little justice to art, as it reduces art's implicit meaning to an explicit intention. The work of art does, however, com-

bine a closed form with an open end, and it can therefore prompt an investigative direction of travel, but can never take it to a conclusion. The method of research in and through the arts is in this sense a game in which different systems can be played off against each other. On the one hand this results in a research report in which a novel insight is formulated, while on the other the experience of that insight is laid bare again in the work of art. This causes the conclusions that were apparently drawn in the text to be suspended again, with the work of art's complexity forcing open the hermetic methodology of science. For its part, the linking of art's arbitrary system of rules with an existing research tradition provides a proof of exigency. Artistic research is a method that facilitates critical reflection on science as well as on art, without denying the respective strengths of these domains.

Reform and Education

Ruchama Noorda

The idea of academia becoming a new podium and laboratory for the arts in Europe is very inspiring. A platform on which art may develop with an autonomy not limited by commodity thinking and the judgment of market forces. A platform where artists may avoid the ill-fitted role of 'cultural entrepreneurs', and develop themselves in relation to broader intellectual and cultural ecosystems. Counter to today's neoliberal climate of ever encroaching privatization, I imagine sustainable institutions where research and critical reflection are liberated from confines of elitism.

As the arts become further integrated into a broader academic system, and the validity of artistic research gains more acceptance in this wider context, the academic world is under attack. Market conditions largely define reforms of higher education.[1] Designed to usher in a competitive socioeconomic model for educational institutions, these conversions of higher education from 'basic-right' to 'luxury-product-of-consumption' serves to deepen social and economic inequalities amongst students and society in general.

I think that the development of edu-

cation must overcome the imbalances of compartmentalized specialization, resist policies of economic inequality, and harmonize the pursuit of knowledge across intellectual, ethical and practical aspects. I believe in equal development of the head, the hands, and the heart. Through significant and characteristic integration of the practical and the conceptual, artistic research holds an important role in regards to the future of interdisciplinary education and the development of academia.

The Historical European Reform Movement − which I regularly refer to in my work − made its appearance in the second half of the 19th century. At its height between 1880 and 1933, it found expression through educational reform, clothing reform, health food, natural medicine, nudism, and new spiritual movements. Within the spheres of fine art, this movement was also essential to the emergence of the historical avant-garde.

The great importance of the histor-

1 The Bologna Reforms to Higher Education, for example, superficially seem to refer to 'progressive-reform education' which gained popularity at the beginning of the 20th century in Europe. The use of terms such as 'mobility' invokes social-democratic ideals of absolute-mobility and widespread economic growth as a guise for the relative-mobility of elitist prosperity. See for example. Bologna Process, http://www.ond.vlaanderen.be/hogeronderwijs/bologna/documents/Bologna_leaflet_web.pdf.

ical reform movement to European art and society can be demonstrated in part by its involvement with the colony at Monte Verità in Ascona. Between 1900 and 1940, this residency, retreat, art-laboratory, and sanatorium was an incubator of research into new-ways-of-living and alternative forms of art. Numerous influential artists and intellectuals were drawn to Monte Verità including Hugo Ball, Carl Jung, El Lissitzky, Hermann Hesse, Lenin, Trotsky, Frederik van Eeden and Ferdinand Domela Nieuwenhuis (co-founder of the Dutch socialist movement). One attendee, Rudolf von Laban, started an alternative art academy at Monte Verità. With a focus on facilitating the design of ones own environment as a total-work-of-art, this reform academy's curriculum sought to '... arouse the understanding and a taste for lively, artistic creation; this is why the student is protected from having to contribute to the number of useless art objects without value: the sad result of one sided art education.'[2]

I wish to propose a contemporary reform movement which reflects the actual ideologies of all those it affects; the support of collective knowledge and activism, open-

source institutions, recreational aesthetics and a self-critical state of continual self-reform. Reforms must be concerned with a living knowledge: actual relationships between people rather than the implications of a cognitive-capitalism.

The connection between my reform research and artistic practice concerns how I locate myself in the art world. The political and ideological aspects of education, reform, and economics always entail social relations and are intimately concerned with exchange and collaboration. Within the form of a process, I regard both artistic research and the artistic product as a moment in time and an exponent of a social interaction.

2 Harald Szeemann, Monte Verità, Berg der Wahrheit: Lokale Anthropologie als Beitrag zur Wiederentdeckung einer neuzeitlichen sakralen Topographie (Milan: Electa Editrice, 1979), p. 143.

The Artist as Researcher
New Roles for New Realities

Graeme Sullivan

Introduction

The purpose of this essay is to consider the position of the PhD in visual art and design within the field of education and the art world. To introduce this topic two related arguments are made: When presented as a form of research, art practice is a site for the creation and construction of new knowledge and understanding; and when art practice is positioned within the research community in higher education, conventional systems and structures that traditionally describe and define research are challenged. Several claims underpin these points:

— Art practice is a creative and critical form of research
— Understanding is an outcome of research and inquiry
— Art practice takes place beyond the paradigms and traditions of social science research
— Art practice as research takes place in a post-discipline environment.

This essay consequently explores art practice as a reflexive form of research that emphasizes the role the imaginative intellect and cultural production play in creating knowledge that has the capacity to transform human understanding.

Claims and Assumptions about Research

Three characteristics of research and the method-

ological assumptions upon which they are based can be seen to give an overview of the changing contexts that frame conceptions of research. The first claim is that *research is a logical and linear process of intervention and inquiry that builds on what we know*. This is a foundational principle of positivist research and is based on the belief that, *if you don't know where you are going how do you know when you get there?* The assumption is that clearly defined intentions, whether expressed as hypotheses, research questions, lesson objectives or standard statements, position the purpose of educational acts within the context of what is already known. Consequently outcomes can be readily assessed according to the conceptual limits imposed as this gives a measure of utility in comparing the new with the old. Knowledge in this sense is expressed as a difference in *degree* or quantity and is compared to other things we know. This has been part of the quest for modernist explanatory systems and describes how we construct probable theory based on the empirical premise that *to see is to know*.

The second claim is that *research responds to issues and problems that need to be interpreted in real-life contexts*. Here, inquiry is based on the assumption that knowledge emerges from an analytic and holistic account through consensus and corroboration where patterns and themes are the elements used to represent complex realities. The methodological assumption is that *problems are not solved, but surrounded*. Knowledge in this sense is explored as a difference in *kind* or quality,

where insights are characterized by their particularity. This is how we construct plausible theory.

Site-based research in the qualitative tradition responds to issues and problems that need to be interpreted in real-life contexts.

A third research claim can be identified, which is one that interests those proposing to introduce studio-based PhD programs. This is the claim that *artistic research can reveal new insights through creative and critical practice.* The claim arises in response to the question about how we construct theories of 'possibility'? A studio-based researcher would more than likely subscribe to the view that *if you don't know where you are going then any road will get you there.* Rather than seeing inquiry as a linear procedure or an enclosing process, research can also be interactive and reflexive whereby imaginative insight is constructed from a creative and critical practice. Oftentimes what is known can limit the possibility of what is not and this requires a creative act to see things from a new view. An inquiry process involving interpretive and critical practices is then possible as new insights confirm, challenge or change our understanding. What is common is the attention given to systematic and rigorous inquiry, yet in a way that emphasizes what is possible, for to 'create and critique' is a research act that is very well suited to practitioners involved in PhD inquiry in visual art and design.

If an agreed goal of research is the creation of new knowledge, then it needs to be agreed that this can be

achieved by following different, yet complementary pathways. Yet this gives rise to some methodological challenges posed for studio-based PhD researchers, such as:

— How are theories constructed that interpret and explain who we are and what we do in visual arts and design?

— How is new knowledge created and communicated?

— What new research methods are needed for the complex visual and virtual worlds of today?

A common institutional strategy for considering the relationship between theory and practice and the goal of constructing new knowledge has been to theorize practice from the perspective of ends and means. Theory-driven approaches to research, however, leave little room for new theory creation and maintain a consistent interplay between low-level theorizing and applied practiced. The influence of means — ends theorizing using problem solving strategies has strong appeal in many fields. In institutional settings a dominant approach to means-ends thinking is seen in the emphasis on problem solving as a core research strategy. Problem solving approaches to theorizing emphasize how learning is a cyclical process and this is also a feature of participatory action research and critical approaches to teaching and learning. However, there is some ambivalence about the pervasive use of problem solving as a pivotal research practice in higher education at the doctoral level. Some theorists

note the limitation of problem solving as a methodological emphasis in design and visual arts research in that even if problems respond to topical issues, a critical stance will invariably get caught within the systems and structures of institutional and professional practices.[1] The contention is that any narrow emphasis on pragmatic problem solving will limit the potential to move beyond instrumental ends.

Irrespective of the methods used for means-ends theorizing, be they problem solving, practical reasoning, or inquiry-based learning, the analysis of the relationship between theory and practice generally remains constant. The principle is based on logical reasoning and assessing how consistent the ideas and concepts are as a basis for translating means into ends, theory into practice, and vice versa. A tactical benefit of means-ends theorizing, however, is that it is outcomes-based as the components of theory and practice can be readily broken down into elements to form policies, procedures and programs. This approach is particularly popular with policy makers, accreditation agencies, and government assessment practices, because it stipulates the terms and conditions that allow any performance to be ranked. Although this problem-driven approach is responsive to change in theory and practice, there are limits to the capacity that new, large-scale theory development can take place. Positioning research practices that move beyond traditional methods of inquiry is an approach that is characteristic of what can be described as the *visual turn* in research.

The Visual Turn in Research

As different conceptions of seeing and knowing were developed to accommodate the more complex realities emerging as the industrial age was superseded by the digital revolution this raised the status of *the visual* as a source of data, ideas and theories. New visual research strategies were developed that cut across methodological and discipline boundaries. As Gillian Rose noted,[2] the limits of the modernist, empirical aphorism, *to know is to see*, was flipped as a consequence of postmodernist thinking because the way we framed reality according to particular interpretive regimes meant that to *know is to see*, and more crucially for studio-researchers, *to know is to see... differently.*

Critical traditions and practices in the arts

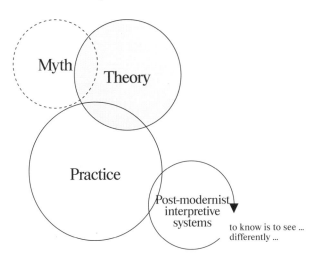

1 Brown 2006.
2 Rose 2001.

Several trends in research methodology and critical analysis that use visual forms as their central motif have emerged in recent years across various disciplines. Within fields such as anthropology and sociology there is a growing use of visual forms as crucial cultural markers that require analysis and critique.[3] An important trend has been the shift to not only collect and analyze visual information, but the realization that visual means of expression and communication can also be created as a means to inquire into human agency within socio-cultural settings.[4] Visual forms of documentation and analysis have also been used to good effect as a means to critique patterns of historical change in areas such as literature, where Franco Moretti's mapping and graphing of the novel has challenged assumptions about genre categories among other things.[5] Within fields of systems analysis and data management the development of immense computing power has also seen the explosion of visual image processing as a language of communication. What has been of singular importance for studio-based researchers arising from these digital developments in visualizing data is the realization that data are not static forms of code, but dynamic arrays of 'living' forms. As Ben Fry notes, 'data never stay the same.'[6]

In recent years art educators have also been exploring visual research approaches across arts disciplines to try to claim a foothold in a knowledge-based educational economy characterized by an exceptionally zealous return to a functionalist research

model. Art education researchers responded to these changing demands and the search for more adequate methods resulted in the development of a slew of new research practices that take many forms. These approaches are being applied at the level of schooling, where research investigates pedagogy in classrooms and tries to capture learning in all its artistic complexity. Various terms are used to describe these developments, such as *arts-based research*,[7] *arts-informed research*,[8] and *A/r/t/ography*[9].

There is a need, however, to be clear about what Eisner and others present as arts-based research. The argument of arts-based researchers is that the arts provide a special way of coming to understand something. The claim, therefore, is that as research methods broaden within the domain of qualitative inquiry in the social sciences, there is a need to be able to incorporate the arts as forms that more adequately represent the breadth of human knowing. The approach taken argues for an expansion of inquiry practices, yet this is undertaken within existing research paradigms. Although proponents make a strong case for educational change that is informed by the arts, there are limits to what can be achieved if the conditions of inquiry remain locked within the constraints

3 Pink 2001, 2006; Stanczak 2007.
4 Goldstein 2007; Rose 2007.
5 Moretti 1998, 2005.
6 Fry 2008, p. 3.
7 Barone and Eisner 1997; Cahnmann-Taylor and Siegsmund 2008; Leavy 2009.
8 Cole, Neilson, Knowles, et al. 2004; Knowles and Cole 2008.
9 Irwin and deCosson 2004.

of social science research. For an inquiry practice that is firmly grounded in the artist's studio the developments commonly labelled *practice-based* or *practice-led* research provide a more theoretically robust basis for application at the PhD level.

Art Practice as Research

A question to be raised here is that as notions of research broaden, how can art and design be a form of research that can more fully account for the breadth of human understanding? For instance, questions about research methodology were key in the development of what became known as *practice-based research* in the 1990s and were answered differently in different fields. As a result, the term practice-based research is found in many disciplines. The thread of usage I find most appealing tracks back to the community health industries in the UK in the1980s. At the time healthcare professionals were struggling to confirm their identity as practitioners committed to constructing new knowledge within the medical and health fields. The randomized controlled experiment was promoted as the only viable method of research. After all, success was evident not only in medical science but also in agriculture where new cures, therapies and remedies were supported by burgeoning industries in pharmaceuticals and agricultural biotechnology. *Evidence-based research* was proclaimed as the only valid way to produce reliable information that could be applied to help cure *ills* and improve health.

Healthcare practitioners, however, knew that much of the knowledge they created in *their fieldwork* emerged from research of a different kind. Because new knowledge was sought from an environment that was generally tilted towards *care* as much as it is *cure*, the evidence that was compiled came as much from practices and experiences, as it did from theories. Hence, the term *practice-based evidence* was invoked as a neat inversion of the mantra of evidence-based research and it drew attention to the quality of experience where the unit of analysis became the patient as much as the problem. Practice-based researchers were responsible for creating and constructing new knowledge that was grounded in the multiple realities and experiences encountered within the lifeworld of individuals. The challenge was to balance evidence drawn from practices built around understandings of the quality of care, with decisions from case-based data and diagnoses about prevention and cure. With ready access to digitized banks of information it was not so much the evidence itself that was the concern, but more an issue of its relevance and how it was integrated into the reality of individual needs.

For those looking to identify how the artist is cental to individual and cultural inquiry the claim is that artistic research has the potential to change the way we see and think. The studio experience is a form of intellectual and imaginative inquiry and is a site where research can be undertaken that is sufficiently robust to yield knowledge and understanding

that is individually situated and socially and culturally relevant. When art practice is theorized as research it is argued that human understanding arises from a process of inquiry that involves creative action and critical reflection. One of the tasks involved in promoting art practice as research is to reconsider what it is that artists *do*. What artists do of course is to make art, and as an object and subject of study art has been well picked over by aestheticians, historians, psychologists, sociologists, critics, and cultural commentators for a long time. But what artists do in the practice of creating artworks, and the processes, products, proclivities, and contexts that support this activity is less well studied from the perspective of the artist. As an *insider* the artist has mostly been content to remain a silent participant and to leave it to others to interpret the relevance of the studio experience. Artists, who are readily able to take up the position of theorists, philosophers, researchers, curators and art writers, make many of the arguments found in the growing literature on *practice-based research* and its popular variant, *practice-led research* Advocacy arguments, historical synopses, research guides,[10] and case studies, in anthologies,[11] position papers,[12] conference proceedings, exhibition treatises,[13] dedicated print and e-journals, on-line research centers, and to a lesser extent theorized arguments in monographs and single-authored texts[14] now fill the ranks debating the significance of artistic research[15].

In theorizing art practice as research somewhat different approaches come into play in artistic

research. Within a traditional social science research strategy theory is both the guide and the goal of inquiry for it provides the conceptual basis for designing interventions and assessing outcomes that can be verified by others. The task is to seek relational or causal connections so as to explain phenomena within the context of existing knowledge structures. However, if the goal of research shifts slightly from *explanation* to *understanding* the role of theory changes. Understanding, after all, is an adaptive process of human thinking and acting that is changed by experience and as a consequence of the forms of media we create and encounter. With this in mind, the research task of wanting to understand things rather than explain them means that the procedures must be more extensive, inclusive and creative.

In theorizing artistic research a basic assumption is that art practice is a means of creative and critical investigation that can be contextualized within the discourse of research. The process of theorizing is a basic procedure of inquiry and hence a core

10 Gray and Malins, 2004.
11 Balkema and Slager 2004: Barrett and Bolt 2007; Elkins 2009; Macleod and Holdridge 2006; Mäkelä and Routarinne 2006; Smith and Dean 2009.
12 Borgdorff 2006.
13 Hannula 2008.
14 Carter 2004; Sullivan 2010.
15 The source of much of the information presented in this paper comes from the new edition of the presenter's text, Art Practice as Research (Sullivan 2010). A website and blog provides additional reference and support for the material presented and represents the idea that artistic knowledge is a liquid form of meaning making that needs to be continually re-interpreted to challenge and change what we know. This rationale is based on the firm belief that artists are a central source for revealing new insights and artistic research is a crucial cultural and institutuional practice that is essential for the creative construction of new knowledge. See: http://artpracticeasresearch.com.

element in research. However, we know that theories are provisional and at best are approximations of reality. The long standing critical function of the arts also suggests that as a form of inquiry the role of artistic inquiry in problematizing phenomena is perhaps the most salient feature of artistic research. In this way, research strategies that are critical not only serve a re-viewing purpose, but lend themselves to creative interpretation as past structures of form and content may prove to be illusionary. Within this creative and critical research space past conceptual systems based on limited notions such as binary thinking, objectified knowledge, essentialist legacies, privileged perspectives and the like, are unable to encompass the new realities explored or created. Therefore theorizing art practice as research establishes a basis upon which visual art and design practice can be seen to be a form of inquiry that is sound in theory, robust in method and can generate important creative and critical outcomes. Several features can thus be identified:

— First, theorizing is an approach to understanding that occurs at all levels of human inquiry and involves creative action and critical reflection.

— Second, theorizing artistic research is a reflexive form of research that emphasizes the role the imaginative intellect and visualization plays in creating and constructing knowledge that has the capacity to transform human understanding.

— Third, artistic research opens up new perspectives that are created in the space between what is known and what is not. Traditional research builds on the known to explore the unknown. Artistic research creates new possibilities from what we do not know to challenge what we do know.

— Fourth, artistic research is a form of human understanding whose cognitive processes are distributed throughout the various media, languages, and contexts used to frame the production and interpretation of images, objects and events.

— Fifth, visual forms are part of cultural practices, individual processes and information systems that are located within spaces and places that we inhabit through lived experience.

— Finally, contemporary artists adopts many patterns of practice that dislodge discipline boundaries, media conventions, and political interests, yet still manage to operate within a realm of cultural discourse as creator, critic, theorist, teacher, activist and archivist.

Agency Structure

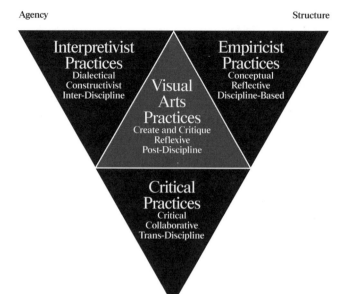

Action

Framework for Art Practice as Research, **from:** Sullivan 2010, p. 102

In the framework above, art practice is the core around which inquiry unfolds. Research draws on knowledge and experience and uses structures of inquiry designed to increase the human capacity to intervene, interpret, and act upon issues and ideas that reveal new understandings. Visual arts research does this in distinctive ways. When seen in relation to surrounding empiricist, interpretivist, and critical research traditions, different practices emerge as artistic inquiry twists and braids in response to purposes and possibilities. This dynamic process opens up several relational and transformative research practices that are found within and across, between and around, the framework, as visual arts research proceeds from a stable to a liquid form of understanding.[16]

In sum, it can be stated that art practice as research is a creative and critical process whereby imaginative leaps are made into what we don't know as this can lead to crucial insights that can change what we do know.

Art Practice as a Post-discipline Practice

One of the important questions to be asked in conceiving of a studio-based PhD is to imagine a conceptual structure that might house the idea and forms in ways that offer some stability and flexibility. In other words, what structure might capture the complexity and simplicity of artistic research? It is argued here that only a *post-disciplinary practice* has the necessary and sufficient conditions to accommodate the philosophies and methodologies that can be envisioned within an artistic research paradigm. Post-discipline practice describes the way artistic research takes place within and beyond existing discipline boundaries as dimensions of theory are explored and domains of inquiry adapted. The discipline perspectives that surround art making reflect ways of engaging with theoretical issues and how appropriate methods might be used to meet research interests and needs. Part of this claim rests on the argument that the edges that once defined boundaries between disciplines as well as differences among artists, critics, scholars, teachers and their audiences have been irrevocably disrupted.

Contemporary artists are not bound by disciplinary distinctions, nor the physical and cultural

16 Sullivan 2010, p. 102.

locations that can limit the perspective of what can be seen anew. Artists function within cultural discourse as creators, critics, theorists, teachers, activists, and archivists. When working from a base in contemporary art, the conceptions of the discipline are uncertain and the informing parameters are open-ended, yet the opportunity for inventive inquiry is at hand. In these circumstances the artist-researcher is seen to be participating in a *post-discipline* practice. Here there is little reliance on a prescribed content base. Rather it is the use of a suitable methodological base that supports the questions being asked, which may take the researcher beyond existing content boundaries. Although the university setting exerts its own disciplinary authority, the challenge is how to be informed by these structures but in a way that maintains a degree of integrity about the post-discipline nature of artistic research.

More traditional systems of theory and knowledge can be seen to be grids of information upon which the hope is to develop stable structures that confirm existing data systems and structures and offer opportunities to build within the spaces to create a more complete picture. Building knowledge from the known to the known is a powerful practice, but there are also other ways to work within and beyond these structures. In some cases there is a need to go beyond the structural solidity of assumed authority. Artistic practice offers the potential to conceive of a liquid structure[17] that opens up new perspectives that are created in the space

between what is known and what is not. As noted above, artistic research creates new possibilities from what we do not know, which challenges what we do know.

The two properties I find useful in conceiving of artistic practice as a dynamic post-discipline practice are *self-similar structures* and *braided* forms. These are described in the diagrams below.

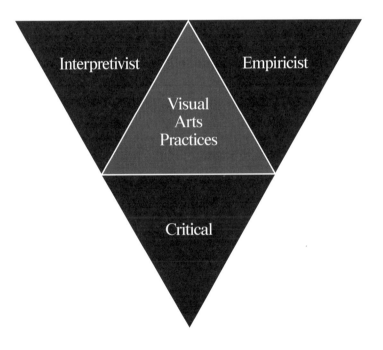

Braided Relationships across Research, from: Art Practice as Research[18]

17 Sullivan 2010.
18 Sullivan 2010, p. 112.

The structure for thinking about artistic practice proposed in *Art Practice as Research*[19] (is composed of a series of interlocking structures that can be separated and re-aligned. One way to visualize art practice as research is to see it as a simple and complex set of braided relationships with powerful generative potential for change. What is proposed is that the braid, with its infolding and unfurling form, disengages and connects with core themes while continually moving into new spaces and this serves as a useful metaphor that captures the liquid structure of artistic research

Artistic Research as a Self-Similar Structure, from: Art Practice as Research[20]

This diagram shows a sequence of images that track what happens when artistic research opens up during studio practice as something new is created. The structure is based on self-similarity because the triangular units endlessly divides and builds upon itself. This reflects how artistic

research responds creatively and criticallly to issues, actions, and changes at all levels of theory and practice. This self-similar feature of artistic research means that it is independent of scale and although it has a similar envelop, it takes on new forms and meanings irrespective of where it takes place, whether in studios, communities or cultures – it is simple, complex and dynamic all at the same time.

The principles of artistic research suggest that there is merit in thinking about the institutional conditions necessary to support studio-based PhD inquiry as being non-linear and non-foundational, and capable of new, emergent possibilities. As such, opportunities for research can be seen to be both informed by existing knowledge structures, but not to be a slave to them. This is a central tenet of the argument that artistic research is an essential part of the thinking to be done within universities in order to open up new ways of responding to pressing issues and to see the impact on existing information structures.

Thinking about the scale-free feature of self-similarity and the infolding explorations of braiding can help us understand the limitations of existing structural forms such as hierarchies, taxonomies, matrices and the like. As conceptual organizers these structures serve as reductive devices that allow us to represent information to assist with easy interpretation and are a key feature of research. Yet not all

19 Sullivan 2010.
20 Sullivan 2010, p. 113.

99

phenomena easily conform to such a structure therefore it is important to consider the forms of representation and discovery opened up by artistic research.

In summary, it can be acknowledged that artistic research comprises practices that are theoretically robust, creatively powerful, ideas-based, process rich, purposeful and strategic, and make use of adaptive methods and inventive forms whose uniqueness is best seen as connected to, but distinct from, traditional systems of inquiry.

References

- Balkema, Annette W., and Henk Slager, eds. 2004. Artistic Research. Vol. 18 of Lier en Boog: Series of Philosophy of Art and Art Theory. Amsterdam: Dutch Society of Aesthetics.
- Barone, Thomas, and Elliot W. Eisner, 1997. Arts-Based Educational Research. In Complementary Methods for Research in Education, ed. Richard M. Jaeger, 2nd ed., pp. 73-116. Washington, DC: American Educational Research Association.
- Barrett, Estelle, and Barbara Bolt, eds. 2007. Practice as Research: Approaches to Creative Arts Inquiry. London and New York: I.B. Tauris.
- Borgdorff, Henk. 2006. The Debate on Research in the Arts. Volume 2 of Sensuous Knowledge: Focus on Artistic Research and Development. Bergen: Bergen National Academy of the Arts.
- Brown, N. C. M. 2006. Paradox and Imputation in the Explanation of Practical Innovation in Design. In Speculation and Innovation: Applying Practice Led Research in the Creative Industries. Queensland University of Technology. Retrieved from http://www.speculation2005.qut.edu.au/Spin embedded.HTM on February 28th, 2009.
- Cahnmann-Taylor, Melissa, and Richard Siegesmund, eds. 2008. Arts-Based Research in Education: Foundations for Practice. New York: Routledge.
- Carter, Paul. 2004. Material Thinking: The Theory and Practice of Creative Research. Carlton, Vic.: Melbourne University Press.
- Cole, Ardra L., Lorri Neilsen, J. Gary Knowles, et al., eds. 2004. Provoked by Art: Theorizing Arts-Informed Research. Halifax, Nova Scotia: Backalong Books.
- Elkins, James. 2009. On Beyond Research and New Knowledge. In Artists with PhDs: On the New Doctoral Degree in Studio Art, ed. James Elkins, pp. 111-13. Washington, DC: New Academia Publishing.
- Fry, Ben. 2008. Visualizing Data: Exploring and Explaining Data with the Processing Environment. Sebastopol, CA: O'Reilly Media.
- Goldstein, Barry M. 2007. All Photos Lie: Images as Data. In Visual Research Methods: Image, Society, and Representation, ed. Gregory C. Stanczak, pp. 61-81. Thousand Oaks, CA: Sage.
- Gray, Carole, and Julian Malins. 2004. Visualizing Research: A Guide to the Research Process in Art and Design. Burlington, VT: Ashgate.
- Hannula, Mika. 2008. Talkin' Loud & Sayin' Something: Four Perspectives of Artistic Research. ArtMonitor 4.

- Irwin, Rita L., and Alex de Cosson, eds. **2004.** A/R/Tography: Rendering Self Through Arts-Based Living Inquiry. **Vancouver, BC: Pacific Educational Press.**
- Knowles, J. Gary, and Ardra L. Cole, eds. **2008.** Handbook of the Arts in Qualitative Research. **Thousand Oaks, CA: Sage.**
- Leavy, Patricia. **2009.** Method Meets Art: Arts-Based Research Practice. **New York: Guilford Press.**
- Macleod, Kate, and Lin Holdridge, eds. **2006.** Thinking Through Art: Reflections on Art as Research. **New York: Routledge.**
- Mäkelä, Maarit, and Sara Routarinne, eds. **2006.** The Art of Research: Practice in Research of Art and Design. **Helsinki, Finland: University of Art and Design Helsinki.**
- Moretti, Franco. **1998.** Atlas of the European Novel 1800-1900. **New York: Verso.**
- Moretti, Franco. **2005.** Graphs, Maps Trees: Abstract Models for Literary History. **New York: Verso.**
- Pink, Sarah. **2001.** Doing Visual Ethnography: Images, Media, and Representation in Research. **London: Sage.**
- Pink, Sarah. **2006.** The Future of Visual Anthropology: Engaging the Senses. **New York: Routledge.**
- Rose, Gillian. **2001.** Visual Methodologies: An Introduction to the Interpretation of Visual Materials. **Thousand Oaks, CA: Sage.**
- Rose, Gillian. **2007.** Visual Methodologies: An Introduction to the Interpretation of Visual Materials, **2nd ed. Thousand Oaks, CA: Sage.**
- Smith, Hazel, and Roger T. Dean, eds. **2009.** Practice-Led Research, Research-Led Practice in the Creative Arts. **Edinburgh: Edinburgh University Press.**
- Stanczak, Gregory C., ed. **2007.** Visual Research Methods: Image, Society, and Representation. **Thousand Oaks, CA: Sage.**
- Sullivan, Graeme. **2010.** Art Practice as Research: Inquiry in the Visual Arts, **2nd ed. Thousand Oaks, CA: Sage.**

Desert Cities

Aglaia Konrad

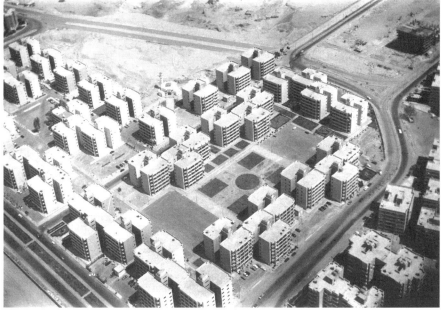

Some Thoughts about Artistic Research

Lonnie van Brummelen & Siebren de Haan

They are involved with their discipline, their colleagues, their students, their sponsors, their subjects, their own and host governments, the particular individuals and groups with whom they do their fieldwork, other populations and interest groups in the nations within which they work. (...) In a field of such complex involvements, misunderstandings, conflicts and the necessity to make choices among conflicting values are bound to arise and to generate ethical dilemmas.

As artists we often work in situ, in an unfamiliar context that we discover as we go along. The outline above is not, however, a description of the artistic fieldwork of contemporary artists, but a quote from the American Anthropological Association's Principles of Professional Responsibility which dates from some forty years ago.[1] And we are not the first to make the link between art and anthropology. In Hal Foster's 'The Artist as Ethnographer', an essay published in The Return of the Real in 1996, he observed that artists and critics were increasingly identifying themselves

118

with anthropologists.[2] According to Foster this identification was a reaction to developments in art (and society) of the preceding decades. Given that the shifts which stemmed from this continue to be relevant, we will summarise them here. The work of art changed from an autonomous object, into an entity that is partly determined by the spatial and physical conditions of perception. The art institution was transformed from a physical location into a discursive network. It became apparent that the public was not a homogeneous, passive group but a heterogeneous multiplicity of participating subjects. And art expanded breadthwise into culture. Postcolonial anthropology had developed into the science of 'alterity'. It was contextual, interdisciplinary and self-critical – and it were these characteristics that artists and critics, with their jointly redefined practice of artistic research, thought they needed in the broadened domain of art.

1 Adopted by the Council in May 1971. Cited in Karl G. Heider, Ethnographic Film (Austin: University of Texas Press, 1976), p. 118.
2 Hal Foster's analogy alluded to a lecture entitled 'The Author as Producer', which Walter Benjamin delivered at the Institut pour l'Étude du Fascisme in Paris in 1934, calling on artists to intervene – as the revolutionary workers were doing – in the means of production in order to transform the apparatus of bourgeois culture.

For us, as for many of our colleagues, speculations, experiments, fieldwork, production, reception and provisional conclusions, in short the process of artistic production which generates dilemmas both ethical and aesthetic, is integral to the work of art.

We were both trained in an era when the debate about 'invisible power structures', as laid bare by thinkers such as Bourdieu, Foucault and Gramsci, dominated the cultural climate, without the body of thought of these intellectuals ever being taught explicitly. Nevertheless, we learned to see Impressionist paintings as status commodities, art museums as machines of discipline and prescribers of taste, and Ancient Greek culture as a symbol of Eurocentrism, as the ultimate representation of values that were imposed upon subject classes by a dominant elite. Because we have internalised the sceptic, we are constantly making sure that we are not being exploited for any agenda whatsoever.

The sceptic would say that by labelling the expanding work of art as 'artistic research' art is commodified as 'knowledge' and thus instrumentalized for the

120

knowledge-based economy, which is meant to strengthen national competitive positions in the multipolar world of the 'global economy'. While we have no desire to disregard the sceptic he appears to have a blind spot: what role can the aesthetic play in a world where positions fix themselves? Artistic research suggests an ethos that appeals to us, namely the open-ended quest for the aesthetic. In an age when 'beyonds' are being created anew − now with the aim of our fending them off − artistic research is stimulating the exploration or eluding of boundaries and prompts us to shuttle between domains that we thought had nothing to do with each other. This means that artistic research is not a discipline but a mentality, not the dominion of artists and critics alone but of the beholder as well.

Surface Research

Henri Jacobs

1

When the Gerrit Rietveld Academy, in cooperation with Fonds BKVB, decided to create a research site for mid career artists and initiated a Research Residency in September 2009, I was awarded the first Rietveld Research Residency. A residency lasts from one to three years and must deal with a clearly defined artistic research project within the framework of the Gerrit Rietveld Academy. The artist will work in the Pavilion of the Academy and will report twice a year on the research project and several educational projects.

A Rietveld Research Residency does not entail research leading to a PhD in Art; it is meant to facilitate concentration on a specific aspect of the invited artist's ongoing work and offers time for the artist to go deeper into theoretical and material details of her or his oeuvre, in the lee of the art market.

My research project is entitled 'Surface Research' and the goldfish bowl of the Rietveld Pavilion is my studio (2). Everybody can observe the Research Resident at work, making him more or less an 'example artist', you can even watch him cooking his dinner in

124

2

the kitchen in the transparent cube. Not always tasty or nice, but cooking has to go on, under all circumstances. Perhaps it is an aid to bemused students to see that it is necessary to sit down and to start, even without any concept, on a theme or subject. It can be interesting to take a sheet of paper and a pencil and simply start drawing. That's already enough.

In this text I would like to describe my Surface Research project. An awareness of the specific properties of surfaces made of paper or canvas were already noticeable at an early stage of my work. A surface is two dimensional and has two sides. Surfaces in art generally have a front that is visible and a back that is hidden. The front side is sublimated by cosmetics of oil color which suggests a frozen or petrified world,

125

very different from our dynamic and ever-changing world. The concept of the surface was well understood and visualized by Diego Velázquez in the painting *Las Meniñas* (1656, oil on canvas, 318 x 276 cm, 3). The painting shows several stories, and the painted gesture by the hand of Velázquez has an almost indifferent kind of arrogance. It is so very well kept in hand and he knows exactly how to brush the paint on the canvas. BUT, painting the other side, the BACK of the painting, or of the mask, or the flat surface, the décor or façade ON the front side, that is done by a genius. *Las Meniñas* is the reason why I started to perforate the linen surface.

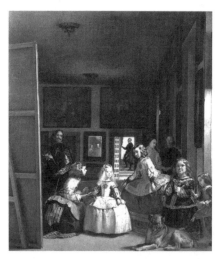

3

I want to show a work (4) that deals with the two sides of a flat surface. In *L'or et l'argent*, shown in De Pont Museum in Tilburg in 1996, it is possible to

4

physically enter the painting by opening one of the two doors in the canvas. When you go beyond the surface, when you pass through the façade or décor, like Alice did by going through the looking-glass, and close the door in the painting, the spectator would see the image shown in illustration 5.

5

The image of a square, of a field of flax. The daylight enters through the two doors and because the canvas stands 20 centimeters from the wall the openings in the surface of plaited strokes of canvas are lit from behind. The doors are painted in silver oil colour and the field is of natural canvas with its specific beautiful colour of flax.

Cultivation and the fabrication of flax into linen brings us to agriculture, to farming and gardening, seeding, pruning, weeding, digging, planting, constantly conducting and organising, to cleaning and maintaining the surface of the earth. In a way all these concepts play a role in drawing and constructing a palimpsest.

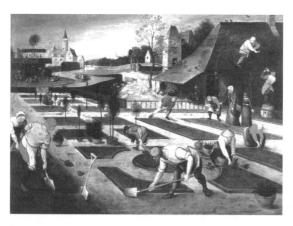

6

The small painting by Abel Grimmer (6) shows how a garden should be maintained. 'The present order is the disorder of the future' is a quote from Ian Hamilton Finlay, who was also a gardener. He had a garden

named Little Sparta which was dedicated to the concept of WAR.'

A palimpsest is a manuscript page from a scroll or book that has been scraped off and used again. The word has come to us through Latin from the Greek; palin means 'again' and 'psao' means 'I scrape'. Palimpsest means therefore scraped clean and used again. Most palimpsests known to modern scholars are parchment because parchment, prepared from animal hides, is far more durable than paper or papyrus. Parchment rose in popularity in western Europe after the sixth century. Writing was erased from parchment or vellum using milk and oat bran. With the passing of time, the faint remains of the former writing would reappear sufficiently for scholars to be able to discern the underwriting (called the *scriptio inferior*) and decipher it.

7

The *Archimedes Palimpsest* (7) was bought by an anonymous private collector in 1998, at Christie's in New York. This collector deposited the manuscript at The Walters Art Museum in Baltimore in order to conserve it, image it, and study it. The book is special because it contains seven texts by the ancient Greek mathematician Archimedes. Those texts and diagrams of Archimedes were discovered under layers of text and painted miniatures in a prayer book.

8

The landscape, the surface of our earth and world is also a palimpsest. This wall (8), with a door and window perforation, built in Museum Jan Cunen in

Oss, is decorated with a satellite photo of Oss and surroundings. The curling of the river Maas is a clear black line and an amazing graphic sign. Even from a distance it's possible to reconstruct the old bedding of the river. In earlier days the river curled much more. But in the late 19th century shorter tracks were excavated to speed the river to its mouth into the North Sea, and reducing the chances of local flooding.

Two months later I painted a short text by Ludwig Wittgenstein on the satellite photo (9). It is a clear text about our longing for knowledge by making theories but finally it is impossible to understand the world in its essence.

Imagine the world as a white surface with black dots here and there... One can put a net with square meshes over the surface. The net makes it possible to describe the dots. It's a grid within the dots are related to one another. Only in the net the relations exist, not in the white surface. You can put different nets over the surface, with a coarse-mesh, a fine-mesh, triangular-mesh or circular mesh-work. Those nets are our theories of the world. They arrange the world so we can describe it. But they reveal nothing.

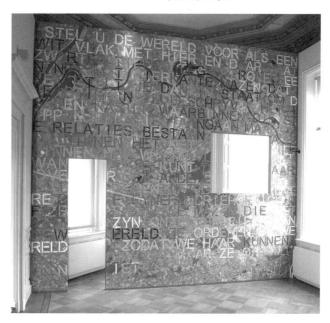

9

Another two months later I painted a quotation of Lieven De Cauter on Wittgenstein's text (10). The text below is an excerpt from his essay 'The Permanent Catastrophe', and it reads like a poem.

The continuing demographic explosion, technological acceleration, global warming, the hole in the ozone layer, the melting of the ice caps, rising ocean levels, the exploitation of the nonrenewable resources, deforestation, the accelerated loss of biodiversity, humanitarian disasters such as the

132

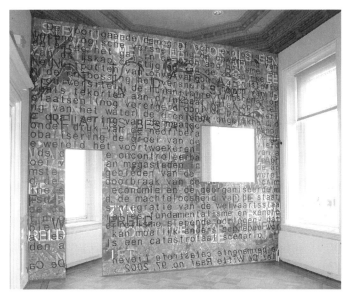

10

shortage of drinking water in many
places (...), growing inequality, the
dualization of society under the
pressure of neo-liberal globalization,
the growth of the Fourth World, the
spread of AIDS, the uncontrollable
growth of megacities in the poorest
regions of the world, the emergence of
the criminal economy and the rise of
organized crime, the impotence of the
state, the disintegration of the welfare
state, migrations, fundamentalism
and xenophobia, terrorism, protracted
wars – all these phenomena, and

133

their feedback loops, are difficult to understand as anything other than as a catastrophic scenario.

Another example of a palimpsest in a landscape is illustrated by four photographs of Fort Douaumont near Verdun in France. Two photos show the fortification when construction was completed in January 1916 (11a-b). The other two photos were taken in October 1916 after the first battle of Verdun and in the summer of 1917, after the second battle of Verdun (11c-d). There are still some very slight traces visible of the original pentagon.

As a different way of looking at the topic of the palimpsest I would like to compare the making of palimpsests with the human writing in the ever-changing landscapes, specifically those changed by enormous violence. At Passchendale and Ypres in Belgium and at Verdun and Douaumont in France during the First World War whole villages of houses, farms, churches, buildings, roads, railways were obliterated, blown off the map, as in entropy, in a short period. The surface of the earth was rewritten with tons of explosives. All that remained were traces, holes and craters.

The text drawn on paper in illustration 12 in this picture is about the Second World War, where the Americans and the British where hunting for the technological secrets of the German V rockets.

In late summer of 2002 the old farm Speelhoven near Aarschot in the region of Leuven, Belgium, held

11 a-d

its annual September exhibition, for which I made nine drawings (13), five of them patterns and the rest palimpsest drawings. All the drawings were laid on the ground and covered with a plate of glass beside a country path. For six weeks, day and night, the drawings were subject to sun, rain, dew, insects, small animals and people.

12

13

Illustration 14 shows the text, designed with ink on 300 grams of watercolour paper after six weeks lying on the soil. The paper was slowly being absorbed by the soil. When I read this text from Thomas Pynchon's book *Gravity's Rainbow* for the first time, about

14

things lying on top of and through one another, I was surprised by the beauty of his list of such a varied assortment of things. The long excerpt of text below describes the surface of a desk of secret agent Tyrone Slothrop. It is like a miniature märklin landscape after bombing. A citation of a few sentences will give an idea of the beauty of the text describing the demolished and destroyed soil of a landscape:

Tantivy's desk is neat, Slothrop's is a godaweful mess. It hasn't been cleaned down to the original wood surface since 1942. Things have fallen roughly into layers, over a base of bureaucratic smegma that sifts steadily to the bottom, made up of millions of tiny red and brown curls of rubber eraser, pencil shavings, dried tea or coffee stains, traces of sugar and Household Milk, much cigarette ash, very fine black debris picked and flung from typewriter ribbons, decomposing library paste, broken aspirins ground to powder. Than comes a scatter of paperclips, Zippo flints, rubber bands, staples, cigarette butts and crumpled packs, stray matches, pins, nubs of pens, stubs of pencils of all colors including the

hard-to-get heliotrope and raw umber, wooden coffee spoons, Thayer's Slippery Elm Throat Lozenges sent by Slothrop's mother, Nalline, all the way from Massachusetts, bits of tape, string, chalk... Above that a layer of forgotten memoranda, empty buff ration books, phone numbers, unanswered letters, tattered sheets of carbon paper, the scribbled ukulele chords to a dozen of songs including 'Johnny Doughboy Found a Rose in Ireland'.

In September 2003 I taught drawing at the art academy in The Hague for several months. To be honest, it was a difficult job to get the students inspired and to get them acting instead of sitting down in despair. One of the tasks I tried to sell was: try to be a camera and at least once a day try to record or capture on paper something that amazed you, that you've seen or thought. Try to draw it quickly and not too big.

In December 2003 I decided to do the same thing myself, after being locked for quite some time into complex and time-consuming large watercolours. I really needed to liberate myself, so I started my *Journal Drawings* on 24 x 36 cm sheets of paper, drawing something seen, thought or heard in one day. It could be anything and everything, without any reference to an archive of images I wanted to explore myself as a bank or database of images.

In *Journal Drawing Number 208, 19 December 2005* (15),
I started to draw the first layer of text by asking myself,
after already having made 207 drawings, why I wanted

15

16

139

to do *Journal Drawings* as often as possible. Putting the question on paper evokes quite a lot of cursing and despair. My conclusion was more or less that it was the TUNE that counted the most, the TUNE and the SOUND in which *Journal Drawings* are drawn.

On top of that first WHY DRAWING JOURNAL DRAWINGS text I constructed a text in a grid of wave-lines (16). The drawing is entitled *Palimpsest Number Two*. But two texts written on top of each other do not make a real palimpsest. It is a multi-layered text drawing without any scratching or damaging of the first text. The same with the satellite photo of Oss and the two painted quotations of Wittgenstein and De Cauter. They weren't palimpsests at all; they were multi-layered paintings of texts on top of a blown-up satellite photo.

One aspect of a palimpsest was clearly there though: after the second layer of text it became quite difficult to read either text. To read the texts instead of looking at the drawing requires their deciphering.

This text is about the Surface, research of, in, on and about the Surface by making palimpsests as the leading principle.

During the Dark Ages, writers had to reuse the parchment or papyrus surfaces that had already been written upon; so the original text was carefully scratched away and a new text was written across it at a right-angle. The residual traces allow the reconstruction of the earlier texts.

The making or construction of a palimpsest, necessarily on a flat two-dimensional surface, means

140

that destruction is an important part of the research project. To recapitulate:

To draw and to erase the drawing.
To draw is to create, is construction.
To erase is demolition, is destruction.
To erase is to scratch away, wipe out,
is different ways of making the con-
structed drawing less visible and more
invisible.
Creation and demolition on a two di-
mensional surface.
I am often lost in contrasts and even
more often in opposites.

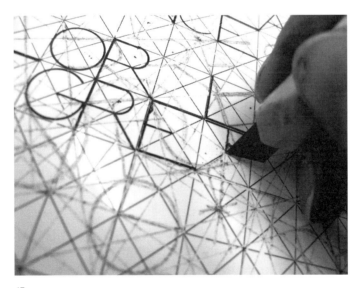

17

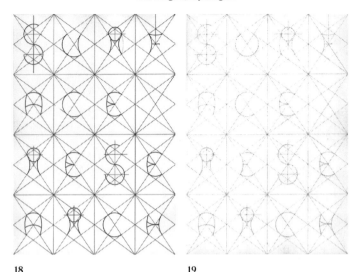

18 19

This drawing on an A4 sheet of Epson Premium Glossy Photo Paper is the first Surface Research drawing I made last September as a Rietveld Research Resident (18). It is drawn with black ink using a ruler, a Rotring technical-drawing pen and compasses. It is a constructed drawing, drawn with straight efficient lines as if by a constructor or architect rather than an artist.

On a new sheet of A4 Epson Premium Glossy Photo Paper the Surface Research title is drawn and than scraped out (19). It isn't a palimpsest yet, because it is still only a single layer. But then it was erased.

To scratch, to erase, to delete, to wipe out, to undo, to damage, to destroy.

Construction and destruction.

Creation and demolition aren't real opposites, in fact the one implies the other. The one exists because of its opposite.

142

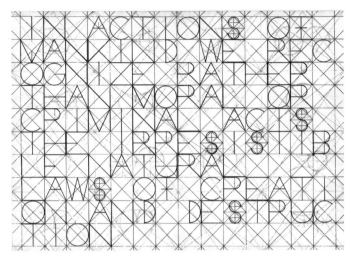

20

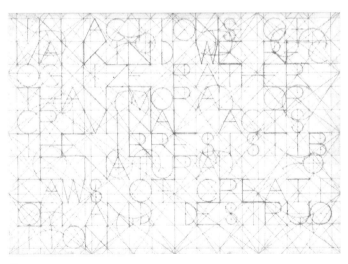

21

Palimpsest Number One (20) dates from 30 September 2009. There are two layers of words here. The first is the title *Surface Research* and is scratched out. The new text is

143

a quote from the Marquis de Sade. 'In actions of mankind we recognize rather than moral or criminal acts the irresistible natural laws of creation and destruction.'

The quote from De Sade is scratched away (21). Two layers of text and construction grids are scratched away but visible traces remain.

What you need to start drawing:

a table and chair
a sheet of paper
a pen or a pencil
a ruler, to be sure of yourself
a pair of compasses, to be unsure of yourself
a notebook, to make notes, or to write words, texts or doodling
some heating in the winter and some food and water in the summer
a longing for simplicity to find the way to simplicity.

Architects consider palimpsests to be ghosts, images of what once was. Whenever spaces are shuffled, rebuilt, or remodeled, shadows remain. Tarred roof-lines remain on the sides of a building long after the neighboring structure has been demolished; removed stairs leave a mark where the painted wall surface stopped. Dust lines remain from a relocated appliance (22). Palimpsests can inform us about the realities of the built past. It is a form of archaeology; the educated

22

reader can decipher the remains or traces and make a reconstruction.

By scratching the texts from the surface the sheet of paper becomes a little field, a small vegetable garden where the soil has been disturbed (23). But it

23

isn't a battlefield; it's too neatly arranged. These palimpsests are like small vegetable gardens between seasons with some force fields of text citations.

Do you need an idea to start drawing or painting? A good question that has no satisfactory answer. Or perhaps the answer could be 'No, you don't need an idea to start drawing or painting'. You certainly don't need a big or even bigger idea, a tiny, simple idea can be enough. For instance, the draughtsman's sheet of white paper. The difficult part is not to get an idea but to continue with a simple idea into the depths of the unknown, as opposed to getting bored after ten minutes. To continue with a simple idea means you have to explore it by making variations and to fail as much as possible.

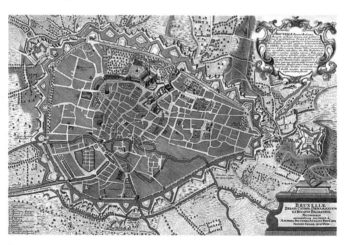

24

After the picture of the scratched drawing in perspective, looking like a landscape in bird's-eye view,

146

I would like to compare and visualize the palimpsest with the development of a city through time, to indicate the impact of man and time.

25

A map of 1740 shows that almost 270 years ago the city of Brussels was ringed by siege walls and moats (24). Through time mankind used and reused his surroundings by constant change and transformation (25). Glancing between the two maps it is possible to find more leftovers and residues of time as well as the enormous transformation of the city over time. The two maps show that beneath the city there remain clear traces of the original footprint. By building and demolishing roads, railways, houses, churches, offices and so on, in fact we are drawing and scratching on the surface of our grounds.

147

26

27

In a constant and everlasting transformation; we have to; we can't do anything else. Without change there is no life. Life is change and transformation, death is standstill.

Illustration 26 shows a palimpsest with three layers of text. The upper layer is a citation from Emile Cioran. 'Each of us must pay for the slightest damage he inflicts upon a universe created for indifference and stagnation, sooner or later he will regret not having left it intact.' Cioran's quote is written on the erased quote, the scriptio inferior, of De Sade: 'In actions of mankind we recognize rather than moral or criminal acts the irresistible natural laws of creation and destruction'.

Written on the scratched title of this research project 'Surface Research' (27).

After studying the maps of Brussels the quote of Emile Cioran is quite special. Here his short text is already scratched out, but nevertheless it sounds like a severe warning: 'Each of us must pay for the slightest damage he inflicts upon a universe created for indifference and stagnation, sooner or later he will regret not having left it intact.'

I don't know how the text continues, but we will regret not having left intact that 'universe created for indifference and stagnation.' Is that why the environmental problems of our time as listed in the poem by Lieven De Cauter quoted above have an almost apocalyptic dimension? Does every time need its own apocalyptic vision?

Surface means it's flat, it's two-dimensional. It

28

hasn't any depth. A sheet of paper has no depth. An illusion of depth on a sheet of paper has no real depth, no surface to dig in. Same with a canvas, a stretched canvas has no depth, it is a two dimensional surface and has two sides. It is a façade, like walls in buildings.

A film projection on a screen is two-dimensional. A light-source projects the depth, the illusion, the narrative, which opens possible wide horizons but stays flat. Do we want to get beyond the surface? Beyond the boundary of the two-dimensional? Do we want to get beyond the veil? As in Plato's cave we want to escape from the boring and already too-long-known reality with its same old wisdoms. And like Alice we want to enter a world which is strange, unknown and spooky, almost a nightmare and that is even better than boring daily life. But Fine Arts are the extra, the surplus, the useless and the unnecessary. They don't

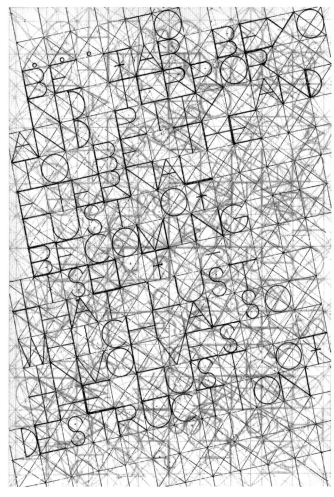

29

force, impose, ask and will not necessarily convince you as a message. At least good art has no message. That is why it is interesting. Because it is open, empty and free. As a viewer you can bring it to life with your own intellectual power.

151

A new layer of text, a quote from Friedrich Nietzsche is drawn on the scratched texts of Emile Cioran and Marquis De Sade (29). Would they agree on being in good company? The force field in the A4 sheet of Epson Premium Glossy Photo Paper through the 3 different texts is becoming more interesting. Nietzsche's text is a quotation from his book *Ecce Homo*: 'to be far beyond terror and pity and to be the eternal lust of becoming itself — that lust which also involves the lust of destruction.'

It is written on the scratched text of Cioran: 'Each of us must pay for the slightest damage he inflicts upon a universe created for indifference and stagnation, sooner or later he will regret not having left it intact.' Written on the scratched-out quote of De Sade: 'In actions of mankind we recognize rather than moral or criminal acts the irresistible natural laws of creation and destruction.'

Written on the erased title of this research project 'Surface Research'.

I have a great desire to be free, so that means that I am captured and imprisoned.
I have a great desire to comprehend, so that means I do not understand the least of it.
I have a great desire for simplicity and clarity, so that means that I am suffering from complexity and chaos.

30

To Draw is to leave traces on the surface of the paper. No necessity of having an idea. To Draw and To Erase. To erase the yet drawn also leaves traces. To Draw and To Erase. To succeed and to fail. Failure is more important, or better: is more interesting, when you fail there is more to do. You can go on. You don't know yet. You're trying to figure out, searching, thinking, wondering. Drawing and failing is like thinking. While drawing concentration works best.

Illustration 30, a work with a detail of Friedrich Nietzsche's Palimpsest, shows the damaged flat surface of the paper, which in certain light looks like porcelain. Often making or creating things, objects, goods, articles of art or design is to add material. Creating is adding stuff on and to itself, on surfaces or mixing it into sculptures, so it's possible to assem-

ble it and to build or construct pieces to a whole. The opposite, which is destruction and finally 'death', is so very interesting even though we don't like it, we ignore it, we don't want to deal with it, we try to forget it.

De Cauter depicts a catastrophic scenario, Wittgenstein lets us know that we can't understand the whole. De Sade is telling us that natural laws reign over cultural laws. Cioran is warning us that the payback time will be soon. Nietzsche talks of our animal behaviour of lust to create and lust to destroy. Yes, the opposite of creation is an important part of creating itself. So that is why in the Surface Research project the scratching is the main subject of research. Which is a destructive and violent act. Well-steered and kept in hand, yet the surface is damaged. It is necessary to become clear about the fascination for such concepts as destruction, damaging, tearing down, catastrophe, violence and death.

These irresistible natural laws of destruction and creation. To create something new is to kill all earlier darlings which delivered satisfactory results. It is more than forgetting or getting over those earlier results, they really have to be totally torn down. Transformation could be the word for this process.

To create is an urge, a bit different from defecation because it is more intellectual instead of animal, but with almost the same urge. To create is a kind of instinct, a necessity that happens in the whole body and not only in the brain. Perhaps creation happens

154

after years of Pavlovian conditioning, or it happens because I am addicted to it, but it is happening in a foggy urge. In a certain mood where unknown and unforeseen things can happen. Curiosity for the unknown is an important motivation.

To create from ideas is quite evident, but an idea is in fact a prison, a superficial prison. To have an idea is already too articulated, it's working with something which is already known. If you want to go deeper, lower, more profoundly into the unknown it's better to be empty, blank, without any idea. Inventions happen in unknown areas or soil. So get rid of ideas, look into the gaping maw of emptiness, where some despair reigns. Then it's going to become interesting, desperation with concentration is the state of being in which an idea-less invention can happen.

After having drawn several palimpsests according to a written plan, it is necessary to reach the border of the principal idea. It's necessary that irrationality can take over the rational idea, to make it absurd for instance, or to make the idea irrelevant. So playing with it can begin, in an ironical or perhaps cynical way. You can laugh with it, destroy the original plan, quit the principal concept. And perhaps it's possible to colonise unknown grounds.

Illustrations 31 and 32 show drawings in a small series with the word 'catastrophe' in the title. The titles are telling you that these are studies after details of small or big catastrophes. For instance the title of the latter drawing is *Etudes de détails de catastrophes*. It

31

is *Journal Drawing Number 287* from 10 November 2006, drawn with watercolour and ink on heavy cotton paper.

It is quite important that several quotes are about catastrophic or apocalyptic subjects. The final reason we live is because we die. I am sorry for the simplistic evidence. *Palimpsest Drawing Number 8* (33) is a plan I wanted to execute. The decision was to keep the parts of the letters which consist of parts of a circle. The result in fact doesn't matter. Whether the drawing is beautiful or ugly, good or bad or boring in-

156

32

stead of interesting is not very important. The illusion of space created by the rewritten black lines with white ink, the remains of words, sentences, texts with ominous content that is now forming it's own composition by accident. This drawing shows the residues after erasing the texts of De Sade, Cioran and Nietzsche.

Starting with a plan, with a decision such as wanting to draw a grid. Longing to draw a grid which is already the thousandth grid drawn by me. Choosing a text which has to fit in the grid, and afterwards wanting to erase the texts by scratching it. It is part

157

33

34

of an overall plan, of an intention, of decisions made beforehand. They are premises and by working within those premises I can leave them, I can free myself from the boundaries created by myself because I don't have any idea nor theme to work with.

Empty as a bottle can be. Creating conditions that can deliver unforeseen results.

158

Illustration 34 shows a detail from the drawing where the Nietzsche citation has been whited-out with white ink. At the end this palimpsest is no more than the residues of circle parts from the different layers with texts.

Palimpsest Number 9 (35): 'Content is a glimpse of something, an encounter like a flash. It's very tiny — very tiny, content.' An old evergreen quote by Willem de Kooning. This drawing isn't a palimpsest but a drawing with five layers of text. De Kooning's text contribution to the drawing, which covers the other three texts about the exhausting existence of mankind, perhaps neutralises the heavy weight of them.

The captured texts may seem quite negative or depressive, violent and aggressive, cruel or without any hope. But I don't agree with that, the texts of De Sade, Cioran and Nietzsche try to look beyond individuality and ego. The texts are written after long observation of mankind and of the own ego as a human being. So I think the texts are quite realistic about human behaviour. These three philosophers try to deal with destruction, demolition, transformation, aggression, violence, dying and death.

Almost all art is an attempt to freeze fluid moments into static or repetitive media, which means freezing or petrifying the dynamics of life and time. So all art deals with death.

At the end of this text I would like to pose a question: What makes somebody start drawing? Is it because there is a slide, a photograph of an image, in

35

the head? And the draughtsman projects it with an inner light through the lenses of the eyes on paper? So the hand can follow the projected lines, the contours of the enclosed areas, that remain the necessary white reservoirs of clean paper? Is drawing giving birth to an idea, is it executing a plan?

Could the first-ever drawing have been a single line drawn with charcoal? Or was it the print of a

36

hand covered with mud? Or the negative of that hand by using a spray of mud over the hand on a stone surface. So, was it a single line of charcoal, the print of a hand, the leftover of a hand? Or could the first drawing have been made by five fingertips dipped in mud to draw five short lines? I suppose there wasn't any idea or plan. The acting person didn't foresee what she was doing, perhaps she was surprised or even enchanted. As in Stanley Kubrick's film *2001 A Space Odyssey* apes were surprised while playing to discover that a bone could be a weapon with which to hit other apes. From that moment civilization was born.

The Surface Research project, which is still working systematically on palimpsest drawings, started as a plan to be executed. A plan, an idea, a concept or a theme are starting points on the path of creating

37

a work of art. Artistic research can help with learning and knowing more about that first plan or idea. Can help to know better what it is about or what already has been done. Because one has to start working on that first idea, plan, theme or concept to which the knowledge built up by artistic research is added, there

38

162

is a risk that the first tiny glimpse of a work dries up. In fact the artist locks himself or herself up in too much knowledge. Some stupidity and naivety is necessary.

Ideas, plans, concepts, themes and research close you in, but starting to work with them has to enable you to go beyond them. Because the artist has to reach into unknown soil of pure intuition, he has to colonize areas and grounds not yet visited. The artist must want to show the unseen and unknown. That is why creation is such an animal-like urge, and drawing is such a direct, impulsive and quick medium. Its simplicity makes it the most excellent medium. Artistic research is alright for concentration on and contemplation of the work already there. That makes it a kind of archaeology, looking back and trying to make a reconstruction. But pure creation is different and doesn't necessarily need artistic research.

When there is the need to create, the need to draw, intuition rings a bell and the best thing to do is to pick up a pencil and put the point of it on paper. Artistic research is like the academic way of drawing after nature where the artist is totally locked up, imprisoned in techniques and educated laws of how to look and how to draw. Captured in KNOWLEDGE. The artist has to go beyond all existing borders put up by plans, ideas, concepts, themes, research and knowledge.

She or he has to try to pass them by and leave them behind. To be able to colonize future soil, not seen and not known before. To arrive beyond the

39

40

41

veil of the ideas. Creation is happening in the colony known as 'l'au-delà'. Artistic research doesn't play a role over there.

Every construction tends to chaos. Every order tends to disorder. Without maintenance entropy does its work. All our constructions of necessities and redundancies are trying to find their most comfortable position, which is lying on the ground as horizontal as possible. None of the materials used want to try to continue standing right up, they are looking forward to lie down and to be as horizontal as possible. They want to find the way to the least resistance, by lying as flat as can be. Entropy is the lust of losing content. Finally we will all be freed from our suffering, even the hedonists.

Artist at work.
Artist at research work.
Artist at work research.
Artist work at research.
Artist research at work.
Research artist at work.
Research work at artist.
Research at work artist.
Research at artist work.
Work research at artist.
Work artist at research.
Work at research artist.
Work at artist research.
At research artist work.
At artist research work.
At work research artist.
At work, artist!

42

The Artist's Toolbox

Irene Fortuyn

The artistic profession involves myriad facets. Art is not restricted to a specific discipline, field of research or method. Every artist chooses his or her relationship to reality, taking the world in all its manifestations as potential material. The work is the means of critically inquiring into that world.

The artist defines his or her own methods and set of tools. The artist's toolbox can therefore contain all manner of things: brushes, paint and canvas, or pieces of wood, chisels and mallets. Or stone, textiles, waste materials, hiking boots, cameras, microphones and measuring gauges. But social conditions, power relations or economic models can also serve as an artist's tools.

In the toolbox one finds those utensils, materials, means and methods that the artist needs to formulate his question and to investigate. The toolbox is used to realise what is necessary for the conveyance, the experience, whether material or ephemeral. Whatever the content of the toolbox, the principle of the artist's profession remains the same: being on a journey with the question. The activity of the artist − the

170

artistry – is not necessarily defined by the outcomes – the works of art – but by that being on a journey, the process of critical inquiry, the context and the transformation, the making manifest. This always entails an investigative component and that is what aligns the artist with researchers in other disciplines.

For an artist who works within the research context the principle of the toolbox remains the same. Perhaps it will be adapted slightly or organised differently, but the essence of the method does not have to differ. The difference is that an additional component is introduced: the artistry and the work that results is not simply practised but is rendered explicit as well; it is the embodiment and the discussion of it rolled into one.

Research has always been integral to artistic practice to a greater or lesser degree, whereas making that research discursive, its introduction within the logic of academia, is not.

The potential of research by artists is great, precisely because they possess a different language and different senses. Yet because this manner of conducting

171

research is currently being developed and crystallised, the boundaries and expectations are not yet clear-cut and confusion can arise. If there is reciprocal curiosity, an open and investigative attitude and the desire to make this form of research an additional aspect of academia – with corresponding funding – then the outcomes and thus the consequences for art (and artistic practice) can only be positive.

However, if this artistic research were to be made part of educational policy even before it has become a defined and crystallised instrument, then there is a potential danger. An invitation to artists with a curious and open investigative approach and a desire for exchange would then be replaced by a practical career requirement. That is accompanied by spurious arguments for carrying out research and will also justifiably arouse suspicion within universities, thus having negative consequences for artistic practice.

During the years of research there would have to be a space within or near the university where the investigations, in whole or in part, can be exhibited or experienced, a space that invites interaction.

Likewise a space where the research activities will be secured for future reference, and where in an open and investigative manner the pursuit of research in the arts is materialised and rendered transparent.

Knight's Move
The Idiosyn-crasies of Artistic Research

Kitty Zijlmans

At the conference *Gimme Shelter* in October 2009 at the University of Amsterdam on the issue of global discourses in aesthetics, someone from the audience asked me if I would send my students to contemporary artworks or contemporary art exhibitions in order to get access to a global study of art. In Leiden, we started to propagate the shift of the study of art history from a one-sided focus on the Western tradition in art to one in a global perspective, that is, to study art from all cultures in time and space. We are not alone in feeling the urgency of this. In the announcement of a lecture giving by an American colleague, world art studies was referred to as 'the only plausible general frame for art history on the global stage in the next fifteen years.'[1] A global orientation takes as its starting point the notion that art is a worldwide phenomenon as opposed to a European experiment between about 1750 and 1960. However, since it is virtually impossible and equally undesirable to present a survey of art across cultures and through history, we need new models of presenting and discussing art in a worldwide perspective. After all, if we would think in terms of an overview of a world art *history*, we would end up presenting only a tiny selection, forging yet another narrow canon (and who will do the selection?); in that case, we would generalize where there is great diversity. In short, because of its inherent linearity and tendency to homogenize, a 'world art history' won't do. Conversely, 'world art studies' — the designation for which we at Leiden University have chosen —

has the plural, and refers to the possibility and the necessity to study art world-wide in all its diversity. Indeed not a small thing to accomplish. Through its combined global and multidisciplinary approach — no single discipline is able to grasp such a broad endeavour by itself — world art studies is creating a new framework or vantage point in the study of art from which to raise many new questions and address older ones afresh. In order to guide research in this budding field of study, in our book *World Art Studies: Exploring Concepts and Approaches* (Amsterdam 2008), we have suggested that world art studies take on three basic themes of investigation that seem relevant once we start looking at the visual arts as a worldwide phenomenon across cultures and throughout history: (1) the origins of art; (2) intercultural comparison, and (3) interculturalization in art.

When discussing these frameworks, I usually point out that for me contemporary art is one of the incentives for the study of art in a global perspective, because it opens up many vistas on the world. These range from the very local and site-specific to the more general, touching upon world issues such as global trade, the environment, or the migration of people. Seen as physical sites of encounter, the artworks act as agents to stimulate discussion and exchange, and to incite further exploration of the themes and subject matter presented. In an earlier paper I referred

1 http://events.berkeley.edu/?event_ID=25573&date=2009-12-04&tab=all_events

to these art works as forms of cultural analysis themselves. The artworks then engage the viewer into a search for his/her connection to the world. In that respect, contemporary art is as explorative an investigation of being human as is world art studies. In the following I would like to further this idea of art as research, and try to explore and to understand the idiosyncrasies of artistic research.

Before elaborating on this, I would like to point out that my thoughts on this theme are quite obviously to be situated within the growing field of artistic research and its increasing literature in various countries in Europe.[2] My entry into this field is from the discipline of Art History and more specifically from my interest in contemporary art and art theory.

Laboratory on the Move

An important incentive for me to really start thinking about what it is that determines artistic research as such, as well as vis à vis academia, was my one-and-a-half-year collaboration with the Chinese-born, Amsterdam-based artist Ni Haifeng in the project 'Laboratory on the Move' (2006–2007). This project was part of the large, national Research Programme *Transformations in Art and Culture: Technologisation, Commercialisation, Globalisation* (2003–2011). One of its sub-programmes was the experimental 'CO-OPs: Exploring new territories in art and science' (*science* here understood in the Dutch meaning of the word *wetenschap* which refers to the whole of academia). In

each of the seven dual projects of the CO-OPs, an artist and a scientist/scholar worked together on a theme of their mutual interest, with the aim of tracing how theories and practices in art and academia can mutually influence each other.[3] Haifeng's and my interest was, and it still is, the relationships between art/art history and the processes of globalisation. The project resulted in several public events, exhibitions, and a number of publications.[4]

The largest exhibition was *The Return of the Shreds* in Stedelijk Museum De Lakenhal in Scheltema in Leiden in the Summer of 2007. The over-arching theme of the exhibition *The Return of the Shreds* was transference — the transportation, exchange, and conveyance of things and thoughts between nations, cultures and people. These movements on a worldwide scale are the effect of globalization, a development which is widely accepted as one of the epochal transformations of the contemporary period. Globalization is a complex, multifarious concept, and is generally used to describe the worldwide economic

2 Most notably the UK, Scandinavia, Switzerland, Germany, Belgium, as well as in the US, but also increasingly in the Netherlands. See: Henk Borgdorff, The Debate on Research in the Arts, 02 of Sensuous Knowledge (Bergen: Bergen National Academy of the Arts, 2006). This is regarded a classic by now. And also: Henk Borgdorff, 'The Production of Knowledge in Artistic Research', in The Routledge Companion to Research in the Arts, eds. Michael Biggs, Henrik Karlsson (New York and London: Routledge, 2010). http://www.ahk.nl/nl/lectoraten/kunsttheorie-en-onderzoek/.
3 See: Kitty Zijlmans, Rob Zwijnenberg, and Krien Clevis, eds., CO-Ops: Exploring New Territories in Art and Science (Amsterdam: Buitenkant 2007).
4 Next to the CO-OPs book (see note 3), see: Ni Haifeng and Kitty Zijlmans, The Return of the Shreds, publication accompanying the exhibition (Leiden: Stedelijk Museum de Lakenhal/Amsterdam: Valiz, 2008), and: Ni Haifeng and Kitty Zijlmans, Forms of Exchange, publication accompanying the exhibition (Sittard: Museum Het Domein, 2008).

system, dependencies and exchanges, and, in their wake, an increasingly developing global capitalist system, which inevitably also encompasses such negative effects as global warming, environmental problems, the depletion of natural sources, global migration, and the spread of global diseases. The antithetical side of this rather depressing picture is the rising awareness and appreciation of local regions and nations. However, *The Return of the Shreds* exhibition was dealing with the aforementioned problems of global trade.

Over nine tons of scraps of fabric formed the gigantic installation *The Return of the Shreds*. In Haifeng's vision, these frayed remnants were in fact returned to the workshop, the former blanket factory Scheltema in Leiden. But there were more connections. For centuries, textiles have been an important trade commodity from China, and today the Western market is flooded with cheap, mass-produced and mass-marketed 'Made in China' clothing. This installation confronted us with the leftovers, which were specially shipped to the Netherlands. The whole machinery and logistics that came with it regarding the codification of goods, obtaining permits, customs declarations, packaging and transportation was an intrinsic part of this work. It connected the trade system to the artwork and hence linked various groups of people, workers, civil servants, museum staff, and audiences. The mountain of shreds was overwhelming, and that it had its effect on people became clear when someone visiting the exhibition exclaimed: 'Is it then never enough?' — referring to the

waste produced by just one moderate factory in China in only one week of production in order to meet the demand for cheap clothing.

Interestingly, in this exhibition the waste from China was turned into an art installation — into something overwhelming and beautiful — but after the exhibition had ended it was processed as waste again, bringing about an equal amount of organizing, logistics and expenses.[5]

I have worked closely with Ni Haifeng but I would never have even imagined to literally visualize quantity, to embody the experience of global trade and its effects in such a way. The physicality of the whole thing was twofold; next to the logistics of moving nine tons of shreds from China to the Netherlands we needed to unload and subsequently unpack the 350 boxes containing the shreds. With five people it took us the whole day, and at the end we were covered in dust and all our muscles were aching. The visitors were confronted with the same physicality of the installation, it was towering over them and it almost burst out of the room. In our collaboration, Ni Haifeng and I were in a sense both creator and analyst, not being divided by the dichotomy of creator versus analyst. Rather, there was a re-mediation between the two.

5 One of the participants of the conference, the visual artist Henri Jacobs (Brussels), made an interesting remark about the Shreds installation. It reminded him of the potlatch, exposing wealth but in the end being destroyed by it.

Inspired by the Muses

In particular the experience of this installation pointed out to me several things regarding the artist's practice which is both mental and corporeal. It is, to paraphrase Michael van Hoogenhuyze, 'thinking with matter' ('denken met materie'), that is, thinking with or through matter, substance.[6] Van Hoogenhuyze was lecturer in 'Denkprocessen in de kunst' (perhaps not entirely satisfactory translated as 'mental processes in art') at the Royal Academy of Arts in The Hague a few years ago. In the book *Het Muzisch Denken* (2007) — in my translation something like 'Thinking as inspired by the Muses' — that resulted from his research into mental/thinking processes in art, he emphasises that this is a kind of thinking not about, but through and in exchange with matter. In the process of creating, an artwork becomes more and more an entity by itself, with its own will if you like. The art work is not just a transfiguration (a 'transubstantiation') of the artist's thoughts and feelings — that would do unjust to the singularity of the material and the work as an entity; it is, or rather it becomes, a presence, not in a spiritualistic sense, but as something which is *there* and demands attention. Many artists mention the dialogical character of creation, in which the material might act as much as a companion, as it can be resistant and recalcitrant. The material — media, objects, texts, space — challenges the artist in a particular way, different from a craftsman or engineer. It transforms into something that wasn't there before

and it presents something particular or in a particular or unusual way. That is why it is noticed. The handling of material (whatever kind or substance) requires creativity and skill, also in one's approach to it. 'Art is a way to make matter think by itself' is one of the headings in Van Hoogenhuyse's book, and I quote from his text, that reads as a series of aphorisms: 'Art is a way of free and associative thinking with matter until the materials/matter justifies itself, speaks for itself, as it were, without the help of the maker.'[7] And from making comes knowing.

In his book *Ways of Knowing* (2000) — which title refers to John Berger's classic *Ways of Seeing* (1972) — John Pickstone outlines the histories of science, technology and medicine, 'not in a single chronological sequence, nor discipline by discipline, but as different *ways of knowing*, each with its own history.'[8] Even though he doesn't exactly refer to art, his study is interesting for this context. Indeed, he refers to the artist only once, but in a inspiring way — I cite the whole segment:

The period around 1800 produced professors of philosophy and of literature, as well as of natural sciences. Even more important was the

6 Michael van Hoogenhuyze, Het Muzisch Denken (The Hague: Koninklijke Academie van Beeldende Kunsten, 2007), p. 11.
7 Idem, p. 71.
8 John V. Pickstone, Ways of Knowing: A New History of Science, Technology and Medicine (Manchester: Manchester University Press, 2000), p. xi.

construction of a fourth new role –
the creative, individual, 'romantic'
artist or writer, who taught new ways
of finding meaning in nature and in
human history. (...) Like other ways of
deriving meanings, and like other ways
of knowing, the role of the artist can in
principle be understood as a means of
intervening in the world.[9]

According to Karin Bijsterveld, professor of Science,
Technology and Modern Culture at the University of
Maastricht, who gave an assessment of the book in
the 'Symposium on Sound' in Leiden in April 2008,
Pickstone responds to the so-called 'two cultures-dis-
cussion', which is both hierarchal and extrapolative:
the Sciences versus the Humanities, science versus
art, art versus craft, etc.[10] However, there is far more
flow between the various fields than this dichotomy-
based representation suggests, and Pickstone pleads
for a heterogeneity (and not a hierarchy) of knowing.
The fields of knowledge-production may have differ-
ent contexts, and social and political conditions have
an effect on what is funded, who decides, and how
and what is recorded, but essentially the various ways
of knowing are potentially 'nested'. After all, as Pick-
stone explains, new ways of knowing are created, but
old ones do not die, they rarely disappear; rather, the
new ones displace the previous ones. Furthermore,
knowledge-formation develops over time.[11] The old

permeates into the new, the new challenges the old.

One of Pickstone's aims is to show 'how ways of knowing were linked with ways *of production* — to ways of *making things*.' He refers to technology, to techno-science, ranging from ways of tending and mending (e.g. agriculture) to defending or destroying (military science).[12] For his field of study, which is STM (Science, Technology and Medicine), he emphasises three ideal ways of knowing: natural history, analysis and experimentalism[13], but in my opinion as a workable set they also apply to the field of artistic research.

First, artworks do not appear out of the blue, but are connected to art histories, to past and present artworks and practices. A multitude of wires links each work to others by the artist himself or herself, and by other artists and producers of images. The artist is part of history and also contributes to it.[14] He needs to know about what has been there, and how he is related to past artistic practices. In one of my lecture series, a few years ago, I invited Fendry Ekel to speak about his art. When one of the students asked him where he came from, he answered 'from art history', whereas

9 Idem, p. 17.
10 This is a discussion that goes back to C.P. Snow's influential lecture 'The Two Cultures' (1959) in which he referred to the frustrated communication between the 'two cultures' of modern society (the sciences and the humanities) causing a major hindrance to solving the world's problems. In 1964 he published a follow up: The Two Cultures: And a Second Look: An Expanded Version of The Two Cultures and the Scientific Revolution.
11 Summary Karin Bijsterveld, expert-meeting 'Symposium on Sound', De Veenfabriek/Scheltema, Leiden 26-27 April 2008, organized by John Heijmans.
12 Pickstone, op. cit. (note 8), p. 3.
13 Idem, pp. 7-13.
14 Cf. Hoogenhuyze, op. cit. (note 6), p. 46.

the student would have wanted to hear his country of origin (Indonesia). I myself was quite pleased with the answer. On the one hand, it doesn't reduce an artist to his ethnic background; and on the other, art has a history as much as it contributes to history.

Secondly, analysis. In the analytical sciences, analysis seeks order by dissection, by tracing the elements. Analysis changes our understanding of things, and one way of achieving this is by comparison. According to Pickstone common things or elements give new frameworks for comparison, but it is my contention that the reversal also applies: new frameworks, such as an artwork, allow common things or elements to gain new meaning in relationship to each other. This is also where the metaphor of the Knight's Move of the chess game applies, it moves in an odd way, a move not known in any other sport. But it is an important move.

Thirdly, experimentalism. Whereas analysis starts from the known, experimentalism starts from the unknown, or rather, the other, the unexpected — bringing together elements to create new phenomena and new insights. This an artistic practice per se. Indeed, artworks can be seen as experiments themselves, ruled by the question: what happens if...? What kind of response or meaning do artworks produce in bringing together the not-obvious or the very obvious but in a different way? In this respect, art always concerns qualitative research. Experimentation and invention go hand in hand, and here the artist and

the scientist meet. They follow their own systems and methods of working, but there is also interaction.

Art ⇌ Science

Martin Kemp, an art historian who is also very know-ledgeable in the field of the sciences, gives an interesting insight into the interplay of art and science in a series of articles he wrote for the magazine *Nature* in the late 1990s. In his introduction he states that for him art and science are not the same thing; rather, 'they well up, in all their various forms, from the same inner necessities to gratify our systems of perception, cognition, and creation.' He too rejects a polar division between on the one hand the scientist as being the one to explain 'why' according to logical analysis, while on the other hand the artist just lets his imagination go without being accountable to a kind of logical scrutiny. That would do unjust to both. As Kemp remarks 'at every stage of the most committed science lie deep structures of intuition which often operate according to what can be described as aesthetic criteria.' Conversely, in the realm of the visual arts, 'the post-Romantic myth of the fiery creator, driven only by passion and instinct, representing the antithesis of analytical sobriety', is even more in need of revision. Many artists think deeply about their work, so Kemp argues, both artist and scientist asks 'why?' insistently. And in the *processes* rather than their end products, science and art share so many ways of proceeding: observation, structured speculation, visualization,

187

experimental testing, and the presentation of a re-made experience in particular styles. These analogies constitute the theme of the book.[15]

A final remark from Kemp's book is relevant for the topic of artistic research: until recently, Kemp remarks, it seemed that 'the "hard" sciences (...) provided the model for all science, and that any science must necessarily strive to operate in a reductionist manner if it was to be seen genuinely "scientific".' This is a requirement that no longer looks so clear-cut, especially since the emergence of complexity and chaos theories.[16] The book ends with the observation that it is not a matter of which type of knowledge production or of gaining insight is right, or more significant, but that each level of scrutiny leads to a different mode of explanation in which the visual plays a pivotal role. Basically the book is about visualizations and manifestations, about visual insights in science and art and Kemp pleads for a situation where art and science speak to each other. For me, that presupposes at least equality and a basis of mutual respect and interest. What both fields share is an urge to advance human understanding, but their modes, approaches and the handling of material differ. Artist tend to develop their own strategy or method of research without the aim of standardization or verifiability.

Homo Poiēticus

There are many ways of accessing and understanding the world: cognitive, pragmatic, empiricist, sensory,

emotive, associative, intuitive ways, through serendipity, theories of knowledge and strategies of research that leave room for implicit, tacit, non-conceptual, non-discursive relations with the world and with ourselves.[17] Modes that allow ambiguity. These are not just reserved for artistic research only, increasingly scholars see theoretical models as modes to open up meaning production, not to close them.

Now, when we designate artistic research as a separate, independent field of research next to and possibly in exchange with other fields of research, I would like to highlight two complementing strategies within that field, on the one hand 'making', or 'creating' as a way of understanding and opening up matter/material. For this practice I would like to borrow a term used by the philosopher Gerard Visser and taken up by Janneke Wesseling in her essay in the CO-OPs book and that is *poiēsis*, Greek for making, building, bringing about, realizing something.[18] The artist as homo poiēticus, which means, thinking while and through creating, or as Janneke Wesseling puts it: making as knowing.

On the other hand, and related to it, is theorizing, the artist as 'theorizer'. There is an immense corpus of artists' text from antiquity to the present, in which artists have reflected on what drives them,

15 Martin Kemp, Visualizations: The Nature Book of Art and Science (Berkeley and Los Angeles: The University of California Press, 2000), pp. 2-4.
16 Idem, p. 179.
17 Cf. Henk Borgdorff in various texts, see note 2.
18 Janneke Wesseling, 'Art as poiēsis', in Zijlmans, Zwijnenberg, Clevis, op. cit. (note 3), pp. 40-42.

on how they perceive the world and on what they consider to be good art. And also on how they proceed and handle material, ideas, context. This kind of theorizing is aimed at providing insight into art — from within, not from the outside as for example the art historian does. Perhaps we can speak of embodied theory in art. This is a valuable contribution to theory, for the field of art as well as for academia. This alone justifies the idea of a PhD in the arts — if justification is what is needed. In his reaction to the article 'Professor Dr. kunstenaar', published in *NRC Handelsblad* of January 29, 2010, an artist remarked that in his opinion one important argument was missing in the discussion of why it would be significant to pursue a PhD in the arts, and that is the enhancement of the quality of art.[19] My response to this would be that serious, in-depth research into a phenomenon and theorizing about it may well augment artistic outcomes, and moreover that writing is material practice also. Theory and practice, research and producing go hand in hand, they mutually strengthen each other. Lastly, and difficult to answer, is the question why a particular research can only be executed by that particular artist.

What can we learn from such an art practice? On a study trip to New York a few years ago I took the students to James Turrell's *Skyspace* in PS1, basically a room in which a large square is cut out of the ceiling so that you look straight into the sky. The students didn't know this and a few were speculating how on

earth this projection of the sky could be so lifelike. A more intense study of the sky they never did.

19 Lien Heyting, 'Professor dr. kunstenaar', NRC Handelsblad, 29 January 2010; Jaap Ploos van Amstel in his response to this article in NRC Handelsblad, 5 February 2010.

In Leaving the Shelter

Italo Zuffi

Something has triggered the need in artists to seek an extended recourse to mental training. A cause of this drift might be the current progressive politicization of the art debate, in response to which artists feel they must develop theoretical tools in order to be better equipped to engage with it.

Another cause might be found in the increasingly aggressive voracity surrounding art and art-related products, which has altered the ambiences by which artists operate, forcing them to shelter in newer unspoiled areas and formats of expression. But if these were the only motives, embarking on a PhD could be merely perceived as a response to a mix of interferences. In fact, a less judgmental survey could simply assign to artists the detection of a promising route, leading to an updated form of hybridization − merging a practitioner and a figure capable of delivering the set of theories that the practice of art can elicit within one individual, within one single body. Will this attempt produce fruitful outcomes? And is the undertaking of such a venture advisable for artists already on a clear path and possessing strong arguments in which to embed their works? Or should they

simply not worry about the production of theoretical grounds in support of their discourse? There can be no easy answer.

My interest in research for a doctorate essentially sprang from the need to explore in depth the implications of my present practice, which appears to be divided in two by an emphasis on the being here, on the one hand, and the development of rather reticent formulations, on the other. A further reason was the desire to see the work inserted into a wider debate, where new levels of argumentation for its theoretical translations can be tested, and from where actions carried out by that system of relationships that receives and re-distributes it can be renegotiated.

Undoubtedly, if the objective is to bring an additional coherence into one's practice, then a PhD can probably help create a general reformulation, or enhancement, of the theories informing the work. Nonetheless, the path may turn out to be limited in its potentials if the general structure is solely arranged through an essentially scientific/academic methodology − a tendency which at present seems to be prevailing over any other option. Hence, if we

were to consider alternatives, there would be room for an additional question: Is it sufficient for a PhD to simply operate as a well organized deliverer of supervision and knowledge (i.e. notions, and the training to manage them)? Or should it stimulate an effective production of experiences as well? Then it could become a place where a set of episodes and exercises, that can not be so easily performed and absorbed outside the course framework, are implemented and shared. The translation of this possibility into an operational method could only be made through an agreement between all the parties involved, both those defining the research strategy and those attending to it. The outcome would reflect the degree of readiness to pursue an uncommon ambition. I imagine this would be an interesting development of the way the PhD has been approached and brought into action so far.

Letter to Janneke Wesseling

Vanessa Ohlraun

Dear Janneke Wesseling,

When thinking about the question of artistic research, I feel, as many artists and curators do, a slight discomfort. It has to do with the terminology used to describe something that artists have been doing since the beginning of humankind, since we know of the production of art. The terminology used within the discursive context of artistic research is relatively new and derives from a field which is not intrinsic to the art world, but to another world, that of academia: academia as in *The University*, not in *The Academy*. This world is offering new and promising opportunities for artists to do what they have always been doing, but in different ways, and thus I support any programme which provides a platform for expanding an artist's practice in a university context. If, that is, the artist can determine the terms of his or her engagement with what is called research in these programmes. And so, I would call for an open relation to the terms of artistic research which allows for artists to formulate what they do with the words they choose, and these might, or might not, include the word 'research'.

As a curator and as a tutor at a postgraduate institute for studies and research in fine art, I see my role first and foremost as that of a conversational partner. It is in the countless

200

discussions I have with artists — be they in the studio, in the classroom, in an art space or at the bar — that my practice as a researcher unfolds. I also think that the artists' practice as researchers finds an important nourishing ground in the conversations they have with cultural practitioners of any kind, including other artists, in these various locations. Research, then, is talking, and talking is thinking.

As you said your publication would focus on the practice of art rather than on theories on artistic research, I found it most appropriate to contribute to it as a practitioner, that is, as a curator. On the website of the PhDArts programme of the Royal Academy of Art it says, 'thinking generates art and art shapes thinking.' This phrase adequately describes the relationship I have with artists such as Hadley+Maxwell, whom I would like to invite, as a curator and by proxy, to contribute to this publication.

Please find attached herewith Hadley+Maxwell's *Verb List Compilation II: Actions to Relate to Actions to Relate to Oneself* The piece is a response to Richard Serra's *Verb List Compilation: Actions to Relate to Oneself* from 1967–68 and lists commonly used verbs that the artists have compiled from recent press releases and artist statements. As Hadley+Maxwell say:

The idea is that one may combine Serra's list with ours to describe contemporary strategies for art production. For example, you can roll something to explore it, or crease to articulate it; you can shave to reveal something or crumple to deconstruct it.

I see this piece as a succinct articulation of the differences in terminologies used by artists in the 1960s and today to describe what they do as artists. While Hadley+Maxwell's list of terms pertains to the currency of so-called socially or politically relevant practices today, it maps out the same shift in the use of language that has lead to the recent use of the term 'artistic research'. It shows how dramatically artists' relationship to language, and practice's relation to discourse, has changed over the last 40 years. In presenting this list beside that of Richard Serra's, and allowing the two lists to be intertwined and entangled, I see a potential of reclaiming a vocabulary that is intrinsic to artistic practice, adding to the mix of possibilities that artists enter as producers or researchers today.

Yours sincerely,
Vanessa Ohlraun

Richard Serra, 'Verb List Compilation: Actions to Relate to Oneself' [1967–1968]

to roll	to curve	to scatter	to modulate
to crease	to lift	to arrange	to distill
to fold	to inlay	to repair	of waves
to store	to impress	to discard	of electromag-
to bend	to fire	to pair	netic
to shorten	to flood	to distribute	of inertia
to twist	to smear	to surfeit	of ionization
to dapple	to rotate	to compliment	of polarization
to crumple	to swirl	to enclose	of refraction
to shave	to support	to surround	of tides
to tear	to hook	to encircle	of reflection
to chip	to suspend	to hole	of equilibrium
to split	to spread	to cover	of symmetry
to cut	to hang	to wrap	of friction
to sever	to collect	to dig	to stretch
to drop	of tension	to tie	to bounce
to remove	of gravity	to bind	to erase
to simplify	of entropy	to weave	to spray
to differ	of nature	to join	to systematize
to disarrange	of grouping	to match	to refer
to open	of layering	to laminate	to force
to mix	of felting	to bond	of mapping
to splash	to grasp	to hinge	of location
to knot	to tighten	to mark	of context
to spill	to bundle	to expand	of time
to droop	to heap	to dilute	of carbonization
to flow	to gather	to light	to continue

Hadley+Maxwell: 'Verb List 2: Actions to Relate to Actions to Relate to One's Audience' [2010]

to explore	to work out	to communicate	to draw atten-
to articulate	to work through	to refer to	tion to
to experiment	to work in	to appropriate	to assume
to uncover	to work at	to expropriate	to disseminate
to navigate	to work on	to antagonize	to connect
to describe	to position	to agonize	to imagine
to compare	to compose	of discourse	to allow
to create	to react to	of dialogue	to elucidate
to deconstruct	to reveal	of belief	to propagate
to construct	to hide	of conversation	to explicate
to confuse	to uncover	of tolerance	to interpret
to destabilize	to orient	of diversity	to mediate
to disorient	to demonstrate	to negotiate	to state
to formulate	to illuminate	to engage	to karaoke
to propose	to use	to categorize	to connect
to stimulate	to put to use	to reject	to strategize
to offer	to make use of	to summarize	of conversion
to consider	to renovate	to juxtapose	of diversion
to focus	to frustrate	to illustrate	of faith
to gather	to make room for	to challenge	of relation
to preserve	to seek	to interrogate	to devote
to deem	to see	to deal with	to organize
to qualify	to look	to investigate	to direct
to quantify	to get at	to penetrate	to invite
to pose	to relate with	to home in on	to narrate
to question	to relate to	to mount	to employ
to transform	to relate	to conceive	to reconsider

203

Painting in
Times of
Research

Gijs Frieling

Artistic research is a concept that is searching for a definition. If it means that artists must assume responsibility for the discourse that is being conducted about their work and must therefore become competent in speaking and writing skills, then I am a great supporter of it. If it means that artists are endeavouring to earn an intellectual status by assuming a model of practice by analogy with the academic disciplines, then I am not in favour of it. This text is an attempt to achieve the former, while the work it is about is a parody on the latter.

My recent installation, Pizzeria Vasari, is an idiosyncratic history of art: a painted display of works of art and artists I admire and have influenced me. The painting, which extends over the walls of three adjoining eighteenth-century rooms at the Museum Jan Cunen in Oss, is divided into three chapters. The first is about the era when visual art was integrated into everyday and religious life. The second chapter is about our day and age, in which artists and works of art have ended up standing alone. The third chapter is about a future age, when a fusing of art and technology

creates new worlds and bodies, on the basis of several characters and scenes from science-fiction movies.

The painting begins with God the Father, as portrayed by Matthias Grünewald in the Nativity panel of the Isenheimer Altarpiece: a large, yellow-red sun with a host of angels flocking around it. The last image is a sort of enormous, three-dimensional timepiece of brown glass, like the one that emerges from the ground of an unspecified planet midway through the film Watchmen (2009, directed by Zack Snyder). Between this alpha and this omega (the clock in Watchmen alludes to Celestial Jerusalem as described at the end of John's Book of Revelation), there unfolds a structure of scenic backgrounds, a midground with figures, sculptures, performances and installations, and a foreground of still-lifes with vases and bouquets, small animals and open books. A festoon of grapevines along the top edge of the mural connects the hundred or so visual quotes.

Pizzeria Vasari is modelled after one of the earliest forms of knowledge production: the descriptive catalogue. The form of the mural – the frieze divided into chapters

with the open art books as notes and glosses — denotes the form of the academic text. In this work, however, the beau ideal of true knowledge — the objective representation of an entity — is exchanged for a chance combination of the author's preferences. It is a parody on art history, an argument of naive and sloppily quoted sources held together by plagiarism, a solemn enumeration of obvious authorities (El Greco, Cézanne, Mondrian), overripe celebrities (Matthew Barney, Thomas Hirschhorn, Gilbert & George) and favouritism (Marie Aly, Job Wouters, Zoro Feigl).

The mural was executed to my design in collaboration with six assistants, who reproduced the visual fragments chosen by me, to a large degree at their own discretion and according to their ability. The inconsistent style and the accumulation of interpretations which therefore typify the work encapsulates its actual message. In our time, which is characterised by an unlimited mechanical reproduction of images, Pizzeria Vasari champions the idea that visual knowledge can only arise if what we think we perceive is processed via one's own soul and the human hand.

Philippe Van Snick

Tiles, Carton, Patterns, 1975
Herbs, Succulents, Agaves, 2009
Composition, 2011

The Academy and the Corporate Public

Stephan Dillemuth

Introduction

As part of his ongoing research project The Academy and the Corporate Public that started in 1999 at the Kunsthøgskolen in Bergen, Stephan Dillemuth looks at institutional research and how it relates to self-organization and bohemia. His research project examines the relationship between the academy (as a discursive field in the fine arts) and the public sphere in the midst of a seismic shift induced by the corporate world economy. Dillemuth claims that this shift ought to go hand-in-hand with a different function for the arts, a different conception of the role of the artist and — this is the big one — a higher quality of education and research.

He asks: What part do students, teachers and researchers play in these developments? Should we try to adapt to this scenario as we see it being rolled out before our eyes, or should we try to resist and change it to meet our needs?

What is Happening Right Now?

The fall of 2009 brought widespread protests and squatting of universities by students, starting at the Art Academy in Vienna and moving on to other countries in Europe and even the US. The occupations were triggered by the failure of the Bologna Process, a failure on all possible levels.

Dillemuth points to the situation in Germany:
— The implementation of BA/MA modules and

credit points marks a break with the Humboldt tradition of which Germany has always been so proud. German higher education was always intended to enable students to engage in a process of self-formation. But now students realize that commercial and technocratic factors are solely responsible for the form their education takes. This comes as no surprise as Bertelsmann, one of the most powerful media corporations, was the instigator of the Bologna Process.

— Student fees have been introduced. Stephan Dillemuth sees this as a first step towards the privatization of education. Whereas previously students were able to study for free, they are now charged about 450 Euros per semester, which may well herald the conversion of universities into profit-making organizations.

— Democratic forms of decision-making within the institutions, referred to in Germany as the Autonomy of Higher Education, have been replaced by corporate business structures that give external members of the freshly installed supervisory boards undue influence over the universities. Managers from such large corporations as Siemens and BMW have been appointed as board members at the university in Munich.

Dillemuth claims that the devastating effects of neo-liberal politics on the arts, the educational institutions and society as a whole have become more and more visible over the years. In light of the global financial crash, people seem to feel that the corporate infiltration into all public sectors, e.g. universities, has gone too far.

SD points to an interesting example of the attitude towards the squatting students displayed by the director of the university in Innsbruck, who called the squatting and what happened around it 'university in the best sense'. SD claims that our educational institutions are in ruins. In the rubble we would find a mix of failed hegemonic projects: patriarchy, neoliberalism and civic society.

In the mess created by the Bologna Process we would find caves and caverns, dark matter and blind spots. Research, as Dillemuth explains, could be seen as a tool for exploring the possibilities and uncertainties of the situation.

Problems and Advantages of Research

Where and how to talk about research? Stephan Dillemuth advocates extreme caution in our approach, to avoid promoting and perpetuating the contemporary hype of research, risking its inflation or even extinction. Certain problems, he claims, assail the position of research in today's higher education:

> — Research has become a justification, especially when it comes to financial problems.

Whenever the word research is thrown in, the money starts to flow.

— A specific jargon is created, a research-funding-legitimation lingo that has polluted all research projects right from the beginning.

— Research has become an obligation in a curricular master plan. Students and teachers are forced into research, thus it has ceased to be any fun anymore.

— Evaluation is problematic; forced research has to be reviewed, and thus evaluation criteria for students and institutions have to be developed. How can we measure the success of research? Through a point system (ECTS and grading), exams, external evaluation?

— Control mechanisms follow the flow of research projects and their entry and exit points. The performance of students is assessed and rated, the institution is assessed and ranked by external companies. Excellence results from streamlining.

— The exertion of control starts from the moment of the decision as to which research projects will be funded and which not, meaning that specific projects may have no chance because they could be seen as too critical or otherwise unwanted by the ruling ideology, which might be deemed preemptive censorship.

— Often only projects that can promise a profit get funding.

225

According to Stephan Dillemuth the predictability of outcome and a forecast yield of the findings seems to run entirely counter to an open-ended process of research.

And finally, Dillemuth emphasizes, none of these consequences are much fun for the researchers involved. They run counter to the process of teaching and learning and to enthusiastic experimentation. Research in such an environment can only be depressing — gone is 'la gaya scienza'.

According to SD, when institutional research is seen as a tool for streamlining and controlling students and staff alike, the outcome will be a predictable affirmation of the ruling ideology, the market economy.

On the other hand, Dillemuth suggests, that research could have many advantages to offer. Research is opaque; it is a journey into unknown territory; it is open-ended and the result is uncontrollable because strategy and methods of research are often determined from moment to moment, or by previous experiments, or frequently improvised, meaning they are unpredictable, despite the wishes of some of those involved. As an example SD mentions Heinz von Foerster, the cybernetics guy , who applied for funding for research projects that he had already undertaken and for which he already had a result. Foerster used the funding to finance another project instead, a brave step into the unknown.

Dillemuth believes that research has to work against its own limitations. Research into the mechan-

isms of control has to be part of research itself. This means that it is necessary for research to control its controller; research can work, *has* to work against its strictures. Research can therefore use unusual methods of resistance: strike, obstruction and protest may be some of them, open- ended experiments that can lead to new and necessary findings.

Entering the field of fine arts, Dillemuth finds an anything-goes attitude in art — an arbitrariness that renders everything equally valid and, consequently, equally boring. In his eyes, the 20th century has done a good job of breaking all the rules and proclaiming the death of art many times over.

As a result anything and everything is allowed as long as it generates desirable new commodities. The array of apparently unlimited differences seems to be wonderful only for the market. In such a situation the art world, like the fashion industry, needs seasonal hypes to make one thing more desirable than the other. The more expensive art it is, the more desired it becomes. The freedom of the market coincides with the freedom of art, and what we get in the end is an endless variety of products with a relatively affirmative entertainment value.

Dillemuth claims that knowledge gained from such proceedings can only be seen as highly questionable. Against art in its function as a mere outfitter for market ideology he proposes artistic research as an epistemological tool, a tool for insight, knowledge and cognition. A tool of reflection

227

about its very own function, a tool against its framing conditions, a tool that might even entertain.

Types of Research

In the following Stephan Dillemuth wants to make himself the object of study in the examination of three processes: self-empowerment, self-organization and research. He suggests three categories of research that are not mandatory concepts, but rather an interpretation of his own development as an artist and researcher: pubescent, bohemian and institutional research.

Pubescent Research

Starting from his student days in the late 1970s SD notes research phenomena or methods that could be called pubescent. Such strategies were used by the punk movement, or more generally, anytime the world seemed pre-defined, pre-determined or inaccessible. From the earliest days, parents, school and the media have been telling us how to see the world, meaning there are hardly any possibilities of taking possession of it; there are no free spaces that can be occupied.

Even in art school despite great promise of self-realization and individual freedom, one will be confronted with the undeniable fact that everything has been done already and all images and strategies already exist. Thus Dillemuth stresses that each young generation may well arrive at the insight that it doesn't have a chance of self-definition! Confronting this

dead-end would be exactly the moment to realize that one's own powerlessness is a chance to act: You don't have a chance but use it!

SD has compiled a list of pubescent strategies:

— It is not necessary to know what you want — it is necessary to know what you do *not* want.

— Test the limits. Where are they, how can they be made visible (provoked), how can they be crossed (transgressed)?

— Position yourself against those who are in power, those who make the rules.

— Ignorance can be useful — Repeat: I know I know nothing!

— Appropriate the means of production! A common demand of the workers' struggle. In the late 1970s, in the arts, painting was the most prominent and culturally charged discipline and could readily be hijacked. Paint was dirt-cheap, and blood-simple to appropriate if done with the right amount of stupidity. Painting could be used against painting.

— A détournement of the code, to use the code against the code: the ugly is beautiful and the beautiful is ugly.

All these strategies were processes of self-formation, self-education and identity-formation. They can be seen as experimental research. The refusal to merely reproduce the old order brought changes in the status of the powerless. Dillemuth calls this pubescent

229

research and sees specific elements of it already present in childhood, e.g. when a toddler crawls on the kitchen floor and drags pots and pans from the shelf to bang them around. The child's mother might take the pots back into place, but five minutes later the scene repeats, an early phase of experimental research that probes the limits of power systems, against all regulations. To try the world against all odds.

Stephan Dillemuth tells us that this is the research model already present in German art academies, and most artists follow it their whole lives; it gives us the image of the artist as the genius dilettante, anti-authoritarian, subjective, singular, individualistic and in some ways naïve. For that reason pubescent research cannot really be called research in the strict sense, for there is no reflection, hardly any evaluation and no consciousness on the part of the researcher.

Bohemian Research

Dillemuth goes back to his vita and gives us an account of a project space that he, SD, together with Josef Strau, Nils Norman, Kiron Khosla and Merlin Carpenter were running in Cologne in the early 1990s. Right from the beginning they found two options to be particularly unattractive: to become a gallerist or to become a producers' gallery. The latter is a gallery run and financed by artists who want to show their own work and that of some friends. In Dillemuth's eyes, this attitude is less self-organization but it is, in its desire to participate in the commodified art circuit,

self-help. He claims that he was interested in a more collective and critical practice where the art-object was to be questioned in its function. Being located in a semi-public situation, the project set out to experiment with the possibilities of the space itself, and the chance to create and encourage a situation of exchange and participation. The space became a meeting point or hangout, which means that there was a community growing around the space and its activities as long as the community determined and sustained it. The space also functioned as an archive that documented and triggered some of its activities.

Back then Dillemuth and his friends saw the space and the activities around it as a kind of model or multiple that could be tried elsewhere. They were finding other people and initiatives that were working in a similar, self-organized way, including fanzines, electronic communication and spaces in Vienna, Hamburg and Berlin.

Dillemuth sees those activities in the light of self-organization and self-empowerment and calls them bohemian research. He provides a list of some of its qualities:

> — located in a bohemian context. The people involved find each other by mutual attraction, by elective affinities; they share the same the problem, but bring varieties kinds of knowledge and cultural background, which might develop into
> — collective work, where the group constitutes more than just the sum of its members, who

231

need to be sufficiently different yet simi-
lar enough for the mutual attraction to turn
into an increasingly differentiated discourse,
which is
— based on the inquiry into the everyday prob-
lems at hand
— self-determined and self-commissioned,
— researching life by living it
— as practiced by every 20th-century avant-
garde group: the Surrealists, Situationists,
Kommune 1, and many more.

Unlike pubescent research Stephan sees collective
methods of self-reflection at work in bohemian re-
search, as tools for self-assurance and analysis (keeping
archives, logs and diaries). Here we find the awareness
necessary for a researcher's self-perception. Methods
for staging experiments, planning strategies and evalu-
ating results may well lead to more experiments.

Dillemuth adds that this period of bohemian re-
search was the experience from which he learned the
most. It became his academy, his art education. He
considers self-organization to be generally an activity
of self-formation and education, of making academy,
which leads him to enquire further about the academy
and its history; self-organization vs. institution; bohe-
mian research vs. institutional research.

Institutional Research

In the following Herr Dillemuth lectures about the

Academy and the University being historically two separate means of knowledge production and dissemination. The development of the University can be seen as three phases:

— The scholastic phase, reasoning for the legitimization and interpretation of Christian dogma.

— The Humboldt University method — knowledge production through research; research and learning go hand in hand; the seminar is a new device for learning in groups.

— The phase we find ourselves in today, of which the description is still being formed. Can we say that today the university is inviting for creating communities around knowledge, or is it delimiting access to knowledge and research, or is it merely job training and technocratic streamlining inside a knowledge corporation?

Right from its beginning the Academy, as a form, represented a different way of learning.

— The Academy in its historical sense was nothing more than a little forest, where Plato and his students would 'hang out'; in the grove, in the groove. Perhaps to be seen as little self-organized meetings, but on land already privately owned.

— During the Renaissance Plato's stance was re-discovered. The Academy in its second phase became a collection of learned societies

233

of amateurs and dilettantes. It can be imagined as a loose and informal gathering for an often interdisciplinary exchange of ideas. The meetings were temporary and not institutional, they attempted to get rid of the old and ossified institutions of the guild system. When eventually they succeeded in doing so, the self-organized learned societies of amateurs and dilettantes created educational institutions themselves, which they called academies.

— Only a hundred years later the institutionalized Academy of the absolutist king came with rules and regulations, with curricular structures and point systems, probably a familiar picture for the absolutist Academy finds its technocratic revenant in the Bologna Process. Not so very differently from the way it works today, the absolutist Academy supplied the court with seasonal styles and delivered aesthetic know-how to increase export options for merchandise.

— Against this technocratic and utilitarian education the Romantic period pitched a return to the idea of the medieval workshop, where the master has the monopoly of education of the apprentices. Conversely, the romantic, autopoetic genius cannot teach how to become a genius oneself — that is why, until today, the Academy has had no

234

method of teaching or any idea of research — learning at the Academy happens by copying the style and habits of the genius/ master. The romantic academy is a place of reproduction.

Dillemuth summarizes that he prefers to see the Academy:
— as self-organized and temporary,
— not as an institution, but
— as a form of communication, and
— as an activity: making academy,
— which means the reciprocity of teaching and learning,
— as a process of self-empowerment.

But then, Stephan asks, what happens to the institutions if everyone can 'make academy' him- or herself? What are the Academies good for? These questions lead him to institutional research?

Again, Stephan Dillemuth takes us back on his vita, and recalls how he entered the institution as a kind of barefooted prophet of the extra-institutional academy. He became a professor in Bergen, Norway, pondering in this enclave whether it was possible to think self-organizationally within an institution. Could it be a tool for critically reflecting upon the institution and possibly changing it according to the needs of the students?

At the same time the Kunsthøgskolen in Bergen

was given a government grant and the teachers were encouraged to think up research projects. Dillemuth was confronted with a research advisor, Halina Dusin Woyseth, who suggested that artistic research might be following its own set of rules and traditions, leaving it totally open as to what that might be, and that she could not be of any help there, because it would probably be something completely different to the traditional university research. She could, however, offer an overview of how research would be structured within a university context.

SD, being curious, asked her to continue:

— We usually start with a problem, she says. Stephan admits he has plenty of problems.

— Research usually starts with an inquiry, or investigation into the questions such as who has worked on the problem already, and how, and what were the results?

— But the process of inquiry is not research, it is only a necessary first step. Dillemuth had a feeling — this was at the end of the 1990s — that many artists were undertaking these kind of inquiries and showing the results in institutions, in the form of photocopies of texts they had read and so on. Obviously they were not doing research, they were simply showing their investigated matter.

— The next step in research is to find and determine a specific view of the problem, a specific idea about where and how to approach it. This

is called the state that has to be questioned.
— Further, the methods to be employed should originate from the researcher's field of expertise. Obviously an artist would use artistic methods before any other.
— Interdisciplinarity makes sense only if there are disciplines in the first place. Interdisciplinarity is not just better in its own right.
— Probably the most important element of research is experimentation. Experiments are necessary to find out if the procedure for approaching the problem works out, and also how the nature of the problem might change through experimentation.
— Probably ninety per cent of all experiments will fail — no worries! — this is inevitable, otherwise they would not be called experiments.
— The reflection of the research process and the evaluation of the outcome of the experiments is extremely important in the research process. Only then can the next experiment be launched.
— There will probably be a sequence of experiments — evaluation, experiments, evaluation and so on — that takes the researcher on a journey into the unknown.
— But who is evaluating this process and its findings? Fellow researchers initially, then a small peer group of experts, then the institutions and the institutionalized critics. A concentric

growth in public perception.

— Exhibitions, manifestos, critical reviews, leaflets, books and other publications may be seen as a part of experimental processes as much as they might help to amplify the public effect of research.

Following this scheme of institutional scientific research, Dillemuth admits his surprise that he could apply everything he had just heard to the field of art in general and artistic practice in particular.

The Academy and the Corporate Public

Being already over time, Stephan Dillemuth continues by hastily introducing the research project that he started in Bergen. He ponders the changes that occur to the idea of the public sphere, predominantly due to the effects of globalization. The national public sphere, in which, ideally, a public debate must take place, is falling apart. Today we have to think of several public spheres fragmented along subcultural, ethnic, gender- and class-related lines, which can overlap, merge, or fall into conflict with each other. Here art and cultural production already play a big part in the analysis and negotiation of problems with identity formation. But what do these fragments have in common? According to SD they are all markets, i.e. they are either already a part of a global market economy, or they are targeted as new markets. Here Herr Dillemuth has spotted a common denominator

that keeps all the fragmented publics together. Does this mean there is a new unity, a new totality on the horizon? And what would that mean for the arts?

Dillemuth continues talking about his project, the relation of research to what he calls the corporate public, and about methods for an art production in a dramatized field. More information can be found on his website http://societyofcontrol.com/research.

Being forced to bring his talk to an end, Stephan finally gives the following conclusion, which we, the editors, will quote straight from his manuscript:

Conclusion

'Finally, artists and researchers, students and teachers, where do you stand? Are we the new court artists? Are we complicit in the new capitalistic rule, representing, promoting and glorifying its triumphant procession around the globe? Is every dissent or criticism absorbed in order to make the criticized stronger and invulnerable? Is there really no other strategy left?

I think research is never neutral, or solely concerned with its own matter. Research has to consider its contexts and what it is doing to them — and it may even succeed in changing them through insights and findings, through experiments. That is why research in institutions is necessary, but limited.

I therefore have to call bohemia to arms! Bohemian research assumes a new and major role as the last refuge for the unrestricted production of knowledge. Bohemian research is:

— driven by need — it results from existential conditions. It is

— self commissioned — it is research into the most important problems of the everyday. It is

— organized

— a crystallization point for critical thought. It is the last place of political dissent and analysis outside general social control.

While the conflicts are growing more acute, we will continue to live in the ruins of patriarchy and neo-liberalism. To shake off its strictures takes perseverance. How can we lay down solid foundations upon which we can construct sustainable knowledge together with others and make it accessible to all? How is this knowledge different from an elitist and technocratic self-acclaimed knowledge society that installs its private claims on the backs of those many billions who still do the dirty work? What we need is research to lead fundamental social change.

Research has to get out of the safe institutions and onto the street. It has to take sides and protect its most important resource — knowledge — against privatization. No patents, no copyright and no controls on access. In order to grow, knowledge has to be made accessible to all and shared by all.

There is so much to do, and research has never been so necessary as it is today. This may be a long way around but it's a whole new game, and a whole lot of fun. Let's go! Now!'

Copyright note: This account of stephan dillemuth's talk is based on some of his notations and a transcript of one of his lectures. because of the poor sound quality of the original recording this text is a somewhat subjective rendering. however, it is authorized by stephan dillemuth himself and can be distributed freely (please do so!) under the creative commons licence, including this endnote. having let it fly, it might happen that its dodgy legitimising potential might be keenly exploited by those it originally set out to challenge. this is why we now invite you, the reader, to consider why it's in whatsoever publication/exhibition, whose interests it serves and the power relations it might help to maintain.

Note from the editor:
This text by Stephan Dillemuth is a reworked version of the lecture that Dillemuth gave at 'The Artist as Researcher' symposium at the Royal Academy of Art in The Hague in February 2009. Dillemuth was keen to retain the style of the spoken lecture. He also opted to publish his lecture in the third person, with a shift of perspective at the end.

Fleeting Profundity

Moniek Toebosch

Ideas come to many artists when they are 'in transit', moving from one point to the next. That is not so much about a specific moment, but about a state of being: a permanent sensitivity to what surrounds them. This investigative approach is open to everything that is 'different', whatever is surprising, remarkable and/or experimental to which this person wishes to relate.

This mental state is often already developed in early youth, but can just as well evolve later, by 'consciously' coming into contact with art or with an artist. For me it was perfectly logical to do something involving the arts, to follow in the footsteps of my father, who was a composer.

The thing I most desired was my own studio, a place where new things could take shape, a physical and chiefly a mental space that was larger than 'outside and inside' combined.

Back then I could never have suspected that fifty years later this physical space would have been reduced to nothing more than a keyboard and a screen. Back then there was the deep yearning for the physical and simultaneously aimless studio space, the profound sense of it be-

244

ing the locus where something could happen. A space where objects, casts, lumps of clay, plaster of Paris, firing ovens, welding equipment and hundreds of little models stand on narrow shelves, a chaise longue and especially the aroma of warm wax. I have never shaken off that romantic image of the studios of my parents' friends, even though the modern-day studio looks very different. I would even venture to state that having one's own studio is the ultimate precondition for happiness, from which everything else stems. It is the professionally magnified happiness of people who have a little shed in the garden and can rummage around there, make or repair something, briefly shut themselves away.

But now that the world around us is changing by fits and starts, in terms of the economy as well as technology, the key question is whether the solitary creation of the artist in the studio will continue to stand up. Whether a good idea springing to mind en route is sufficient to earn it the right to exist. How artists can continue to be relevant when the new world citizen is seeking solace somewhere other than in art. And whether the artist of today can

still avoid the world as stage by shutting himself away within his own oppressive bastion.

The question of what the artist actually ought to be searching for is therefore becoming increasingly pressing.

Is it because of the artist escaping the isolation of the studio to pursue a doctorate that the academic world is now turning its attention to the work of art in order to fathom out what is scholarly within the work? And is it possible that this research also alters the work and even the atypicality of the artist? That he might be rendered more tangible (and more comprehensible), more transparent, because the work, besides being good art, must now also serve as the visual onus of proof of what has just been asserted?

Research aside, the artist is constantly searching for the shockwave in order to surprise, by adopting novel and much more radical positions that will exceed the above-mentioned 'sensitivity' many times over. The fact is that many artists are reinventing themselves. This means that they must become involved with the new world to a much greater extent than before, must

immerse themselves in new norms, must ask themselves where and in what form they can meaningfully contribute to the community and to the arts. They must blaze a trail with solutions that provide insight into new constructs and render them manageable. Even, yes even if he would have to become Prime Minister, or I the new Queen, in order to achieve this! In a spare hour, he and I can flee to our shed or studio, to scrawl something on a piece of paper or to scratch into a little crown as a nominal act of resistance.

And, And, And So On and So Forth

WJM Kok

ARTISTIC RESEARCH – these two words easily make one forget that the word 'art' is used here as the root of an adjective, as if art is to be at the service of research. What if we try to reverse this set-up and change it into researchistic art? Unfortunately the suffix '-ist' (-istic) is simply not allowed in combination with 'research'. However, the affix '-ist' and its related '-ism' are both very productive in forming new words, not the least in relation to art movements. We can think of classicist-classicism, dadaist-dadaism, stuckist-stuckism, situationist-situationism, among others. Nevertheless, there appears to be no appropriate suffix to turn the word 'research' into an adjective, making it impossible to have it obediently sit next to art as its servant. Does this status quo favour research as something more powerful and sovereign than art? Rather, it seems to show the lack of flexibility that art happens to be so well endowed with. Perhaps the survival of artistic research might best be guaranteed if it becomes a new art movement called Art Researchism. Yet we do not want to fall into the same trap as Stuckism, with one of the two initiators of the movement – the more talented one –

250

escaping before it really started.

ART AND RESEARCH – these two words easily make one forget that the two become three now. This third word 'and' rings a bell; the bell of the all-inclusive magic word of Deleuze and Guattari. Difference and Repetition is the book Deleuze wrote as a kind of preparation to the indiscernible but no less persistent 'and' affects and effects. Amongst many other things, it made clear that the good old days of doing research were over – starting and ending with philosophy. With the quickly growing interest in his writings today, this now seems to have become relevant to a completely new range of... and, and, ...till the nth degree number of disciplines.

ART IS NO NATURAL SCIENCE – an ambiguously demarcated statement on a sign in Witte de With art space in Rotterdam, exhibited as part of a fabulous show by Cosima von Bonin entitled: COSIMA VON BONIN'S FAR NIENTE FOR WITTE DE WITH'S SLOTH SECTION, LOOP # 01 OF THE LAZY SUSAN SERIES, A ROTATING EXHIBITION 2010–2011. Possibly this sign expresses something of the resistance to the new develop-

251

ments of research in art. Germany, the country where Von Bonin lives and works, happens to be one of the last bastions in Europe that is still not amused by the Bologna accord. Perhaps for good reason, but such massive political influences will simply fail to be resisted by opposition only. Opposition is dependent on judgement by comparision, as simplified in the form of the mathematical equation. The determination 'is', 'I am', '=' seems to have lost its relevance in quantum mechanics, just as much as in most of recent continental philosophy and contemporary art. Things today are to be observed as events. Deleuze and Guattari call them 'becomings'. However it doesn't suffice to make simple transpositions like ART BECOMING NO NATURAL SCIENCE, neither with its affirmative counterpart ART BECOMING NATURAL SCIENCE, nor for its reciprocal positions. Rather it aims for an ART MEETS NATURAL SCIENCE BECOMING MORE ART and vice versa et cetera.

And, And, And So On and So Forth

A Blind Man Sometimes Hits the Crow

Barbara Visser

I

The use of the wonderful term *researcher* has over the course of time been claimed by scholarly practice, or has in due course been naturally ascribed to it. Non-scholars are indeed at liberty to describe their work or hobby in this way, but if it becomes evident that the research in question is oriented towards a more subjective conception of the world, then it suddenly sounds slightly pathetic and quasi-important.

Artistic practice is not even mentioned in the Dutch-language Wikipedia entry for *onderzoeker* — a 'researcher' in the broadest sense: 'A researcher is someone who investigates unknown things.'

Without elevating Wikipedia to the measure of all things — factual knowledge has, paradoxically enough, become slightly less important due to its democratisation — it is painful to ascertain that what you personally regard as the most important aspect of the visual arts, namely the deployment of alternative research methods and the introduction of alternative forms of logic in order to arrive at novel insights, is not even mentioned in the definition of the word *onderzoek* — 'research'.

The unique way in which the visual artist acquires knowledge, gains insights and conceives images is barely acknowledged, neither among makers themselves nor between makers and the public. The intentions of all parties in the visual arts — in spite of a few attempts that have been dismissed as 'overly elitist' — seem to be increasingly limited to actual visibility and

256

socio-economic interests. Art plays a marginal role in the public debate and in our social sphere? It is an autonomous island, which is a condition that offers many advantages, such as maintaining a certain distance from commonplace conventions and expectations, but on the other hand, when the discoveries you make on that island no longer reach the mainland, as an artist you will have to go and investigate: what type of vessel are others using to approach their goals?

My love of research is so profound that at a given moment I have to force myself, time and again, to allow the process into which I have launched myself to congeal. Whenever I yield to the request to make public the ever-dynamic research and conform to the static model by means of the 'exhibition' — a model about which I sometimes wonder whether it continues to have any justification whatsoever — I feel a bit of a fraud. It represents a snapshot presented as a conclusion.

Should I renounce it? No. The temporary halt, even if it is performed to order, is also a reference point. Should the work unexpectedly be bought, then that particular congealment is conserved in time. That always gives me cause to take a gulp, but at the end of the day it is pleasing that someone takes care of that moment, as I am personally incapable of doing that: I have no intention of establishing a mausoleum of snapshots!

In an ideal world the material and the narrative symbiotically merge, and even I still believe

in this when lying in bed at night. Thank goodness third parties occasionally force me to make a statement, otherwise my research would extend into eternity, constantly branching off in directions that, in principle, are all equally interesting and valuable.

II

In the spring of 2008 I was presented with the opportunity to exchange thoughts with R.D., an eminent scientist. Given his demanding function as President of the Royal Netherlands Academy of Arts and Sciences he was difficult to approach, but it was primarily his role as a researcher of string theory and quantum gravity, poised on the boundary of mathematics and particle physics, which attracted me. In addition, his scientific career was preceded by a flirt with the art academy, though journalists this is always and everywhere mention this with a bit of a snigger. As an artist in constant despair about my working methods, it seemed to me that I could learn a few things from the cast-iron logic to which scientists *pur sang* like him hold the patent.

Permanently ashamed about the inconsequentiality of my profession, fumblingly searching for urgency, wandering around with the courage of despair in a cloud of serendipity and passing through one associative crossroads after the other, the artist is an impotent observer of the ostensibly more meaningful process of deduction and verification in science.

It may well be impossible to apply a crystal-clear

rationale to the fine arts, but it nevertheless seemed to be worth taking the trouble to investigate differences and similarities in the practice of art and science. After all, art's mantra is 'a blind man sometimes hits the crow'.

In order to turn a dream conversation with R.D. into reality I had to phone his secretary. On the other end of the line she searched for a time slot in his diary and offered me an appointment the following Monday morning, from precisely 8.40 a.m. to 9.25 a.m., in R.D.'s study. There was an audible incredulity in her voice, which betrayed the fact that she thought our meeting/appointment even taking place was inconceivable. I held my peace for a moment: a mere 45 minutes for a conversation with a total stranger. 'That's quite short', I said, in order to gauge whether there was any leeway. 'Don't you worry about that. Mr D. is exceptionally quick-witted', she responded *ad rem*. 'It won't be *his* wits that need more time', I said. 'You'll have to make do', she replied. 'I've been trying to do *that* for years', I quipped.

The conversation with R.D. proceeded as awkwardly as one might expect when an artist, a scientist and an egg-timer are shut in a room together early on a Monday morning. Towards the end of the conversation, which had overrun by at least five minutes, R.D. proposed/suggested our talking further on another day. I thought that was sympathetic but also fairly naive of him: he evidently didn't know what his own schedule looked like. 'Can you really just do that?' I

asked, but he obviously had a better grasp than his secretary of the fact that exchanging information and time slots are not the be-all and end-all, because he then leaned forward and said in a hushed tone, 'I'll put a *ghost appointment* in the diary.' This gave me the first inkling that we were on the same wavelength.

During the first meeting, rushed by the clock, I had come straight to the point: in order to be able to think and look beyond the existing frontiers, artists and scientists operate from a metaphorical island. Subsequently, there on that island, there arises for me a growing frustration about the fact that I am lacking the connection with the world for which it is all intended. R.D. expressed this much more eloquently: 'Both science and art have traits of a parallel universe, with its own rules and laws that are connected but feebly with everyday reality. And perhaps also with a universe where it is somewhat more pleasurable to spend time, because certain laws simply do *not* work there. But on the other hand, the value — of science, for sure, but in my view of art as well — is that it reflects upon that everyday reality. In order to understand something you cannot be too deeply ensconced in your subject; you have to take a step back and look at it in a different way.'

During our *ghost appointment* at a café-restaurant set in Amsterdam's medieval weigh-house, I blurted out that time is in fact the only luxury that both the artist and the scientist can, or must, permit themselves. That was, of course, prompted by my being so

260

pleased that R.D. had employed his intellect — let us call it horse sense, at least — to make more time for a conversation based on a pretty vague premise.

D. stated that the only reason for bringing a project to an end is because at a given point it is time to allow a shift to something new. 'If you obsessively pursue a particular idea for too long, then the law of diminishing returns kicks in. It's very easy to add yet another small detail, a little variation on the theme or the umpteenth generalisation, but at a certain point there is simply no more flavour left and then you have to stop. However, in and of itself you can never know too much about something.'

> BV: *There's a cliché that the more you know, the more you realise that you actually know nothing.*

RD: That's true. Conversely, I often wonder how it is possible that there are always people who manage to add something new anyway. I think that's all down to the researcher's individual character. Of course people very often create the illusion that science is purely objective, but science is what scientists do: you cannot see knowledge as something detached from the way people react to all that knowledge, to what already exists. And researchers often have a highly personal signature, an idiosyncratic angle that is inimitable. Even in a rigid discipline like physics you can find great physicists ascribing human traits to nature. 'Nature is fond of elegant things', for instance. What we consider as

science *pur sang* is actually a kind of compilation of all those personal impressions.

> BV: *But people surely try to be as objective as possible in science?*

RD: Only the facts are objective: the structure of DNA, the age of the universe or the mass of a particle. These are all givens, but the whole point is your endeavouring to explain *why* that is the case, and such an explanation is always personally biased. That process of elucidation is something that people do; nature itself has provided no explanation for why it is put together like that, and it never shall. The scientist produces the narrative based on the bare facts.

> BV: *You always have to leave room for chance, a sort of controlled coincidence; you have to be able to recognize what you don't know yet. Let me give you one example. I was supposed to create something for De Vleeshal museum of contemporary art in Middelburg. For someone who grew up in Amsterdam, like me, traditional costume is attractive but in a literal, superficial way: the manifest form was the only thing that fascinated me back then. I wanted to do something with that, make a short film. At the same time I had to set up an exhibition in Athens, so I had the traditional costumes from Zeeland sent there. I had a clear idea of what I was going to do with them* in situ, *but*

when the parcel arrived and I unpacked it in my hotel room I noticed that I didn't have the faintest idea of where one single component of the costume belonged within the ensemble. There I stood with all those pieces of lacework and straps, and I realised that this was what it was all about. At such a moment the lack of knowledge probably says more about your perspective on Dutch culture and history than all the things that you do know about it; revealing the lacunae can also say a lot.

RD: That's a great example, because in this case the material — all those components — also embodied a distinctive narrative — in this case an ambiguous narrative, because the separate components suddenly suggested many more possibilities. That has something to do with what I definitely think is the most interesting interface between art and science, namely the process, the research. The process is in fact already in dialogue with the material — something which can be very tangible in the visual arts and sometimes rather less so in science — but in both instances it is people who are conducting the discourse. I'm intrigued by the tussle that this entails.

BV: *Do you know what you are searching for in your own field?*

RD: No, I don't. For young scientists in particular it is difficult to accept that uncertainty. The training is

clearly delineated, certainly in science: the most important goal of absorbing all that knowledge during your studies is to obtain as perfect a grade as possible in exams. However, you are constantly looking in the rear-view mirror, for knowledge gained previously. When you start conducting research yourself it is difficult to suddenly have to look through the front windscreen, because what do you see there? Nothing!

D. pointed out the resilience that is needed in order to achieve results, certainly in art: the fact that everything is possible turns it into a struggle in search of the outer frontiers as well. 'The practice of scientists has changed dramatically, but then in the opposite direction: the boundaries are becoming ever narrower. A thinker in Ancient Greece, even in the 17th century, cheerfully mixed together all the disciplines. In my own field, even a century ago a mathematician or a physicist could still be active across the full breadth of the discipline; now the prevailing idea is that you can actually only engage with something if you really know all the facts and, because those facts are multiplying exponentially and knowledge is probing ever deeper, at a certain point you essentially no longer know anything about anything else, except for your own little sub-field, that is. The expertise is so sharply defined that you're considered an amateur if you take a single step to the left or right.'

BV: *But doesn't it sometimes constitute a huge added*

value if you can establish a number of connections that are not the most self-evident?

RD: I think that you can justifiably ask whether science isn't doing itself short with that emphasis on detailed expertise. The scientific world is now so containerised that many fields no longer cross each other's paths. That is an impoverishment. If you look back then it is easy to imagine that great scientific breakthroughs would never have been made if people had not pursued such a broad range of interests and looked beyond the boundaries. Every generation consistently complains that the next is even narrower in its outlook, and that trend seems irreversible.

III

Research is intrinsic to good art, but there is a difference in outlook about the *status* of that research.

While one artist limits himself to presenting an outcome, a fictitious end point, another type of artist regards his or her work as an ongoing narrative. I personally belong to the latter group. On the face of it this might seem slightly modish or elitist, but that is not the case at all. Although the concrete form of this sometimes dovetails less successfully with the criteria (not wholly unreal) of validity, legibility or presentability in the private sphere, the work is sincere in its attempt to describe something more than what the autonomous object comprehends, and thus renders itself vulnerable as well. I actually associate fashionability

265

and elitism with arming oneself, with the creation of distance.

It is certainly not an easy position, because the expectations and desires across the whole field are still ultimately typified by a fairly narrow definition of what art practice, art education and art consumption involve. It is as if we are supposed to be embarrassed by anything that is not straightforwardly quantifiable, a concept of quality, for example, or the sense of something that extends over a longer period of time, such as the gradual amassing of knowledge. Utilitarian thinking governs everything, it seems.

One of the greatest qualities of art, albeit rarely mentioned specifically, is that there is leeway to establish connections that are by definition made nowhere else, because in the pragmatic world there is no immediate cause for this, and the reason for this does not correspond with a conventional setting of objectives. It offers no prospects of a quick return. New combinations of knowledge, interaction, material and processes, an unorthodox collaboration between parties with their own specialisms, might lead to radically new insights. Besides making *things*, the artist can also accomplish something else: bring together different forms of knowledge and insight like an orchestrator.

Art ultimately centres around ideas and assuming responsibility for interconnecting them, which is, in fact, demonstrated by every interesting work of art.

267

Acknowledgments

This publication was made possible with the financial support of the Mondriaan Foundation and thanks to a generous grant from the University of the Arts in The Hague. I would like to thank Frans de Ruiter, Director of the Academy for Creative and Performing Arts at the Leiden University, and Jack Verduyn-Lunel, Chair of the Board of Governors of the University of the Arts in The Hague, for their stimulating support and for the fact that they enabled me to produce this book. I am profoundly grateful to the authors and to the artists who provided visual contributions for their dedication and enthusiasm, and I am deeply indebted to Erica van Loon and Tamara de Groot, who have been indispensable members of the team. Metahaven I want to thank for the accurate and attractive design. Last but not least, I wish to express my gratitude to the book's publisher, Astrid Vorstermans, for her confidence and unflagging encouragement.

Janneke Wesseling

Acknowledgements

Contributors

Jeroen Boomgaard (1953) is Professor of Art and Public Space at the Gerrit Rietveld Academy Amsterdam and head of the Masters course in artistic research at the University of Amsterdam. He obtained his PhD with distinction in 1995 for a dissertation on Rembrandt and his place in Dutch art history.

He publishes regularly in the Netherlands and abroad on questions of the avant-garde, art and public space, and artistic research. Among his recent publications are *Highrise: Common Ground. Art and the Amsterdam Zuidas Area* (Amsterdam: Valiz, 2008), *The Magnetic Era: Video Art in the Netherlands 1970–1985*, co-edited with Bart Rutten (Rotterdam: NAi Publishers, 2003) and *Als de kunst erom vraagt. De Sonsbeektentoonstellingen van 1971, 1986 en 1993*, co-edited with Marga van Mechelen and Miriam van Rijsingen (Arnhem: Stichting Tentoonstellingsinitiatieven, 2001).

Jeremiah Day (1974) graduated from the art department of the University of California at Los Angeles in 1997 and lived and worked in Los Angeles until moving to the Netherlands in 2003 to attend the Rijksakademie. Day is currently pursuing a Doctorate of the Arts in collaboration with the Vrije University in Amsterdam and the Utrecht Graduate School of Arts. His work has been included in *Manifesta* 7, and in group exhibitions at Kunstverein Hannover, Kunstlerhaus Stuttgart, the Stedelijk Museum Bureau Amsterdam and Autocenter in Berlin. Day is repre-

sented by Ellen de Bruijne Projects in Amsterdam and Arcade, London. He is currently producing a new commissioned performance with *If I Can't Dance*.

Stephan Dillemuth (Büdingen, D, 1954) teaches at the Academy of Fine Arts in Munich (D). More info: www.societyofcontrol.com. Download the film *The Hard Way to Enlightenment*: societyoutofcontrol.com/download.html

Irene Fortuyn (Geldrop, NL, 1959) worked in close collaboration with Robert O'Brien (Bromyard, UK, 1951 – Leiden, NL, 1988) as Fortuyn/O'Brien from 1983 to 1988. After his death she continued to work under the name Fortuyn/O'Brien until 2005. Since then she has been working as Irene Fortuyn.

The Fortuyn/O'Brien collaboration began with the publication of the manifesto *Bon voyage voyeur, Gedachten over Sculptuur* (Bon voyage, voyeur. Thoughts about sculpture) in January 1984. Central to this text and the work they created together was the issue of the position of the work of art and the possible perceptions of it.

Following a solo exhibition at the Stedelijk Museum Amsterdam in 1991, their work manifested itself outside the context of institutional art with ever greater frequency. The place where the work is situated, both mentally and physically, is constantly questioned, displayed and elucidated through the work. Besides providing a location and a basis for sculptural

installations, the landscape and the public space also became a theme of investigation.

Besides Fortuyn participating in the Venice Biennale and Documenta IX, her work has been presented in solo exhibitions at the Maison de la Culture St. Etienne, the New Museum in New York, Stedelijk Museum Amsterdam, The Showroom in London, Witte de With in Rotterdam, Kunstverein Hamburg and ICA Philadelphia.

Her realised projects include works in the Wilhelminapark in Amsterdam, at the City Hall in The Hague, the Dutch Embassy in Berlin, the Peace Palace in The Hague, and the Berkel en Rodenrijs Baked Landscape.

Irene Fortuyn is Head of the Man and Leisure Department at Design Academy Eindhoven and is attached to the Royal Academy of Art in The Hague as a lecturer.
www.irenefortuyn.nl

Gijs Frieling (Amsterdam, NL, 1966) produces murals and paintings. He studied at the Rietveld Academy in Amsterdam from 1986 to 1991 and at the Rijksakademie in Amsterdam from 1994 to 1995. He received the Dutch Royal Award for Painting in 1994, the Prix de Rome in 1999 and the Cobra Prize in 2009. He has been attached to the Rietveld Academy, the Sandberg Institute, the Rijksakademie and de Ateliers as a (guest) lecturer. From May 2006 to May 2010 he was director of W139 in Amsterdam. He is currently

serving as the visual arts advisor to the Chief Government Architect. His mural *Pizzeria Vasari* (2010) can be seen at Museum Jan Cunen in Oss (NL) until the end of 2012. He lives near Nijmegen.
www.gijsfrieling.nl

H a d l e y + M a x w e l l have been collaborating since they met in Vancouver, Canada, in 1997, working in a variety of media including installation, sculpture, video and sound. Stemming from their commitment to collaboration, their work examines mediation as the threshold between the individual and the social. Their recent body of work, titled 'Improperties', engages with a history of the decorative arts and its reluctant relationship with conceptual processes of categorization. Their writing and image-based projects have appeared in publications including the *Fillip Review*, *Art Lies!*, *Public*, *C Magazine*, and *F.R. David*.
www.hadleyandmaxwell.net

H e n r i J a c o b s (Zandoerle, NL, 1957) has been living and working in Brussels since 1993. He studied at the St. Joost Academy in Breda, the Academy for Visual Arts in Rotterdam and the Rijksakademie in Amsterdam. From the autumn of 1990 he spent a year as an artist-in-residence at the Van Doesburg House in Meudon, France. His paintings and drawings have been presented in solo and group exhibitions in galleries and museums in Brussels, Bruges, Amsterdam, Rotterdam, Eindhoven, Tilburg, New York, Paris and Venice.

The oeuvre of Henri Jacobs now includes various small- and large-scale art commissions in Amsterdam, The Hague and elsewhere. Since December 2003 he has been producing a constant stream of drawings. He regularly posts these *Journal Drawings*, for which he employs himself as a visual database, on the 'Journal' pages of his website. Since September 2009 Jacobs has been engaged in a two-year artistic research project at the Rietveld Academy in Amsterdam. The first year involved practice-based artistic research about the palimpsest, which was followed by an investigation into creation and destruction. That artistic research has evolved into a study about idolatry and iconoclasm.
www.henrijacobs.be

W J M K o k (Utrecht, NL, 1959) studied at the St. Joost Academy, Breda, the Academy of Art and Design, Enschede and the Rijksakademie in Amsterdam. He exhibits regularly in museums, art spaces and galleries and is represented by Galerie van Gelder, Amsterdam. Over the years he has received grants from the Fonds BKVB, the Prix de Rome and the Royal Award for Painting. His work is in museum and private collections. He is working on doctorate research at Leiden University. W.J.M. Kok is a lecturer at the Gerrit Rietveld Academy, a researcher in the Department of Artists' Theories and Art in Practice of the Royal Academy of Art, The Hague.
www.galerievangelder.com/artists/kok2.html

Metropolitan urban space is fundamental to the photographical work of A g l a i a K o n r a d (Salzburg, A, 1960). Since the early 1990s she has focused on urban landscape and megacities. She has had solo shows in Siegen, Antwerp, Geneva, Graz, Cologne and New York and has participated in such international group exhibitions as *Cities on the Move*, *Documenta X*, *Orbis Terrarum: Ways of Worldmaking* and *Talking Cities*.

Her book *Desert Cities* (Zurich: JRP|Ringier, 2008) marks the final phase of a long-term project *Egyptian New Cities* for which she was awarded the Albert Renger-Patzsch-Award in 2006. Her books include *Elasticity. Aglaia Konrad* (Rotterdam: NAi Publishers, 2002) and *Iconocity, Aglaia Konrad* (Cologne: Verlag der Buchhandlung Walther König/Antwerp: De Singel, 2005).

F r a n k M a n d e r s l o o t (Utrecht, NL, 1960) is an artist who has been working in Amsterdam since 1983. His work, which is embodied as sculpture, reveals the unstable meaning of things because of their fluid state and status, depending on the context and different uses. The work is a reflection on its own status as a work of art and the value systems that influence its reception.

There have been solo exhibitions of his work at the Bonnefanten Museum in Maastricht, Museum Boijmans Van Beuningen in Rotterdam, the Centraal Museum in Utrecht, the Stedelijk Museum Bureau Amsterdam, the Museum of Contemporary Art in Sydney, and the

Rijksmuseum Twenthe in Enschede. Mandersloot is attached to the Gerrit Rietveld Academy and to the Master Artistic Research at the Royal Academy of Art in The Hague as a lecturer.
www.frankmandersloot.blogspot.com

The film installations of Aernout Mik (Groningen, NL, 1962) have been shown in solo and group exhibitions over the past 15 years, and are held in numerous public collections. His key exhibitions over the last decade have included solo shows at the Stedelijk Museum, Amsterdam (2002), the Ludwig Museum, Cologne (2004), the New Museum of Contemporary Art, New York (2005), Kunstverein Hannover (2007) and Hamburger Bahnhof in Berlin (2007). In 2007 he represented the Netherlands at the Biennale in Venice. The Museum of Modern Art in New York presented an extensive solo show of his work in 2009. From 2011 to 2012 the Jeu de Paume in Paris, the Folkwang Museum in Essen and the Stedelijk Museum in Amsterdam will show Mik's retrospective solo exhibition *Communitas*. Aernout Mik lives and works in Amsterdam.

Ruchama Noorda (Leiden, NL, 1979) studied visual arts at the Royal Academy of Art in The Hague (BA 2002) and the Sandberg Institute in Amsterdam (MA 2004). She made her debut in 2003 with the exhibition *The Profitable Art of Gardening* in Museum Het Domein in Sittard. In recent work she has been inves-

280

tigating the desirability of an all-embracing ideology in an idiosyncratic *Gesamtkunstwerk*. Noorda's work involves both installations and performances. She has been carrying out visual research into 'ReForm' since 2009, as a doctoral candidate at PhDArts. www.ruchama.com

Vanessa Ohlraun is the Course Director of the Master of Fine Art programme at the Piet Zwart Institute, Willem de Kooning Academy and is based in Rotterdam and Berlin. In exhibitions, lecture series and seminars she has been concerned with issues of postcolonial studies, histories of modernity and feminist theory, as well as performative practices within the context of contemporary art.

Vanessa Ohlraun studied Art History, Cultural Anthropology and Gender Studies in Freiburg, Seattle (USA), and Berlin. Previous to her appointment to the Piet Zwart Institute, she was responsible for the visual art, film and new media department of the Canadian Embassy in Germany. In this capacity, she collaborated with numerous artists and curators from Canada and Germany, introducing artists such as Luis Jacob, Brian Jungen, Geoffrey Farmer, and many others to the European art scene. Exhibitions she has curated include *I Wanna Be A Popstar* (2004) with, among others, Rodney Graham, Kevin Schmidt and Althea Thauberger, and *Staging Rebellion* (2005) with Alex Morrison. Furthermore, Vanessa Ohlraun co-directed the independent art space Center in Berlin, where

she curated solo-exhibitions of emerging artists.

Ohlraun is a member of the editorial board of *A PRIOR Magazine* (www.aprior.org) At Piet Zwart Institute, she has edited and published numerous publications, including a collection of essays by Jan Verwoert, *Tell Me What You Want, What You Really, Really Want* (Berlin: Sternberg Press/Rotterdam: Piet Zwart Institute, 2010).

Graeme Sullivan (1951) is Professor of Art Education and Director of the School of Visual Arts, Pennsylvania State University. For the past 15 years he has been exploring visual artists' creative and critical thinking and making processes. He has described his ideas in his groundbreaking book *Art Practice as Research: Inquiry in Visual Arts* (London: Sage, 2005), which underwent a major update and revision in a new edition published in 2010 (www.artpracticeasresearch.com). He is also the author of *Seeing Australia: Views of Artists and Artwriters* (Sydney: Piper Press, 1994). Graeme Sullivan maintains an active art practice and his *Streetworks* (www.streetworksart.com) have been installed in several international cities and sites.

Moniek Toebosch (Breda, NL, 1948) is a visual artist, performer, actress and musician. Since the 1960s she has initiated several media projects in collaboration with many other artists. Most of the projects are temporary interdisciplinary works in public space, museums, theatre and on Dutch TV.

She is known for her music theatre solo *They Say She's a Singer* (1978), the performance *Joyful Anticipation* at the foundation De Appel (1978) and *Attacks of Extremes* (1983), four live transmissions on Dutch national TV in collaboration with the Holland Festival and the Angel radio station: Angels FM 98.0, along the dyke between Enkhuizen and Lelystad (NL, 1994–2000). From 2004 to 2008 she was the director of DasArts in Amsterdam, master of theatre, a hybrid of education, production and research. She has recently tutored PhDArts researchers for visual artists in a collaboration between the Leiden University and the Royal Academy of Art in The Hague. She is presently creating new artworks in public space. Several new exhibitions can be expected in the near future. www.moniektoebosch.nl

Lonnie van Brummelen (Soest, NL, 1969) and Siebren de Haan (Dordrecht, NL, 1966) have collaborated since 2002, producing film installations and exhibition projects that explore the boundaries of the public realm. In an attempt to encourage the viewer to re-appropriate uncertain grounds, their silent films peruse the tones, movements and textures of such cultural and geopolitical landscapes as Europe's new borders (*Grossraum*, 2005), sites of global trade (*Monument of Sugar*, 2007) and the non-sites of cultural heritage (*Monument to Another Man's Fatherland*, 2008). In their films the formal aesthetic of the silent surface is countered by textual supplements that

disclose the contingency of their fieldwork and institutional research.

Their works have been presented in Palais de Tokyo, Paris, Kunsthaus Zürich, Argos, Brussels, the Shanghai and Gwangju Biennials, and are included in the collections of Stedelijk Museum Amsterdam, Museum of Modern Art, New York, Filmmuseum Amsterdam and Hoffmann Sammlung, Berlin.

Hilde Van Gelder is associate professor of modern and contemporary art history at the Katholieke Universiteit Leuven (B). She is director, together with Alexander Streitberger (Université catholique de Louvain), of the Lieven Gevaert Research Centre for Photography (www.lievengevaertcentre.be) and editor of the Lieven Gevaert Series (Leuven University Press) as well as of the open access e-journal *Image [&] Narrative* (www.imageandnarrative.be), part of Open Humanities Press. Van Gelder is a member of the editorial board of *A PRIOR Magazine* (www.aprior.org), which was selected for *Documenta Magazines* in 2007. She recently published *Photography Theory in Historical Perspective: Case Studies from Contemporary Art* (Chichester/Malden, MA: Wiley-Blackwell, 2011), co-authored with Helen Westgeest (Leiden University).

Philippe Van Snick (Ghent, B, 1946) is a key figure in the Belgian art scene. In 2010 he presented a comprehensive overview of his work in Museum M in Leuven (B), accompanied by an extensive catalogue

that underlines the importance of his oeuvre. Some of his themes of are the day-night pattern, symbolized in the colors blue and black. Van Snick limits the use of colour to the ten-colour palette of red, yellow and blue as main colours, orange, green and violet as secondary colours, gold and silver as colours with physical value and black and white as non-colours.

Solo exhibitions include *Territorium* in S.M.A.K., Ghent, Museum Dhondt-Dhaenens, Deurle, Stedelijk Museum De Lakenhal, Leiden. Group exhibitions include *1979: A monument to radical instants*, Barcelona, Witte de With, Rotterdam, and several exhibitions at MuHKA, Antwerp. Philippe Van Snick lives and works in Brussels.
www.opk-vansnick.be

From the beginning of her career, B a r b a r a V i s s e r (Haarlem, NL, 1966) has been occupied with the relationship between registration and dramatization. Vissers' work is driven by fascinations concerning original and copy, historical narratives and constructed biog-raphies, which she translates into what she calls subjective documentaries.

By questioning the authenticity of images and their interpretation by the viewer, she simultaneously influences the shape and the content of the work. Her projects are executed in photography, film, video, text, printed matter and performance. Infiltrating existing systems and media leads to a diversity of works, ranging from a guest role as a Dutch artist in a foreign

drama series to a work on a Dutch postage stamp.

Barbara Visser studied photography and audio-visual arts at the Gerrit Rietveld Academie in Amsterdam, the Cooper Union in New York and the Jan van Eyck Academie in Maastricht. Her work has been shown internationally since 1992 and is represented by Annet Gelink Gallery, Amsterdam.
www.barbaravisser.net

Janneke Wesseling (1955) is Professor of Art Theory at the University of the Arts, The Hague, and co-director of PhDArts at the Academy for Creative and Performing Arts, Leiden University. She writes art criticism for the Dutch daily newspaper *NRC Handelsblad* since 1982.

In addition to her work for *NRC Handelsblad*, Janneke Wesseling has published widely on contemporary art in catalogues and magazines in the Netherlands and abroad. She has also published a number of independent studies, as well as a selection of her art critical texts: Wesseling is currently working on a dissertation about reception aesthetics and contemporary art.
www.jannekewesseling.blogspot.com

Kitty Zijlmans (The Hague, NL, 1955) is Professor of Contemporary Art History and Theory at the School of Art History at the Leiden University. Her main interests are contemporary art, theory and methodology, focusing on the contribution of women to art and culture, as well as on processes of global-

286

ization and the increasing role of intercultural dimensions in art and the art world. Her publications include *World Art Studies. Exploring Concepts and Approaches*, co-edited with Wilfried van Damme (Amsterdam: Valiz, 2008); *CO-Ops: Exploring new territories in art and science*, co-edited with Rob Zwijnenberg and Krien Clevis (Amsterdam: De Buitenkant, 2007); she was editor of *Site-Seeing: Places in Culture, Time and Space* (Leiden: CNWS Publications, 2007).

Italo Zuffi (Imola, I, 1969) is a visual artist who employs sculpture, performance, text-based work and video to create 'no total design, just an indefinite series of stanzas' (Pier Luigi Tazzi, 2003). He studied at the Academy of Fine Arts in Bologna (diploma in Painting, 1993), and at Central St Martin's College of Art & Design, London (Master of Arts, 1997). In 2001 he was awarded the Wheatley Bequest Fellowship at the Institute of Art & Design, Birmingham. Presently a PhDArts candidate at the Academy of Creative and Performing Arts, Leiden University, he is focusing on the notions of Aesthetical Competition, Indivisibility, and the Hyper-lyrical. He lives in Milan.
www.italozuffi.com

Index of Names

A Aly, Marie 208
 Archimedes 130
 Arendt, Hannah 8-11

B Ball, Hugo 76
 Barney, Matthew 208
 Benjamin, Walter 119
 Berger, John 183
 Beuys, Joseph 7, 19, 20
 Bijsterveld, Karin 184, 185
 Bourdieu, Pierre 120

C Campus, Peter 24
 Carpenter, Merlin 230
 Cézanne, Paul 6, 208
 Cioran, Emile 149, 152, 154, 157, 159
 Courbet, Gustave 19

D De Cauter, Lieven 132, 140, 149, 154
 De Kooning, Willem 159
 De Sade, Marquis 144, 149, 152, 154, 157, 159
 Degas, Edgar 52-55
 Deleuze, Gilles 251, 252
 Dillemuth, Stephan 14, 222-224, 226-232, 235, 236, 238, 239, 241
 Domela Nieuwenhuis, Ferdinand 76

E Eisner, Elliot 87
 Ekel, Fendry 185
 Elkins, James 9

F Feigl, Zoro 208
 Ferneyhough, Brian 69
 Feyerabend, Paul 58, 59
 Fliervoet, Maartje 68, 69

Foster, Hal 118, 119
Foucault, Michel 60, 120
Fry, Ben 86

G Gilbert & George 208
Goldberg, RoseLee 24
Graham, Dan 28
Gramsci, Antonio 120
Greco, El 208
Greenberg, Clement 18
Grimmer, Abel 128
Grünewald, Matthias 207
Guattari, Félix 251, 252

H Haacke, Hans 28
Hadley+Maxwell 201-203
Hamilton Finlay, Ian 128
Hegel, Friedrich 5
Heller, Agnes 33
Hesse, Eva 28
Hesse, Hermann 76
Hirschhorn, Thomas 208

J Jacobs, Henri 181
Jung, Carl 76
Kant, Immanuel 9
Kemp, Martin 187-189
Khosla, Kiron 230
Kubrick, Stanley 161
Kuhn, Thomas 58, 59

L Lenin, Vladimir 76
Lissitzky, Lazar El 76

M Maharaj, Sarat 4

Manet, Edouard 6, 18
Michelangelo 18
Mondrian, Piet 208
Moretti, Franco 86
Morris, Robert 28
N Nauman, Bruce 28
Ni Haifeng 178-181
Nietzsche, Friedrich 152-154, 157, 159
Norman, Nils 230
P Picasso, Pablo 6
Pickstone, John 183-186
Plato 150, 233
Pollock, Jackson 18
Popper, Karl 58, 59
Pynchon, Thomas 136
R Raphael 18
Reagan, Ronald 7
Rembrandt 18
Rietveld, Gerrit 52
Rose, Gillian 85
Rubens, Peter Paul 6, 18
S Sander, Ed 19
Sekula, Allan 25, 35
Serra, Richard 201-203
Smithson, Robert 28, 68
Snow, Michael 28, 185
Snyder, Zack 207
Souriau, Etienne 29
Strau, Josef 230
T Talbot, William Henry Fox 28

Thatcher, Margareth 7
Titian 6
Trotsky, Leon 76
Turrell, James 190
V Van Eeden, Frederik 76
Van Hoogenhuyze, Michael 182, 183
Van Snick, Philippe 25
Vanvolsem, Maarten 24, 27-31
Velázquez, Diego 6, 126
Visser, Gerard 189
Von Bonin, Cosima 251, 252
Von Foerster, Heinz 226
Von Laban, Rudolf 76
W Wesseling, Janneke 31, 32, 189, 200
Westendorp, Johannes 68, 69
Westgeest, Helen 30, 31
Wittgenstein, Ludwig 131, 132, 140, 154
Wouters, Job 208
Woyseth, Halina Dusin 236

Index of Subjects

A Academia 18, 19, 74, 75, 171, 172, 178, 179, 190, 200

Art academy 76, 138, 222, 258

Art criticism 5, 239

Art education 2, 9, 13, 31, 74-77, 80, 81, 83, 87, 124, 222- 224, 232, 234, 266

Art institution 119

Art world 3, 8, 32, 77, 80, 177, 200, 227

Artist 2-9, 12-14, 18, 20, 25, 27-29, 32, 35, 38, 58, 60-62, 64, 65, 68, 74, 76, 89, 90, 91, 93, 95, 96, 118, 119, 121, 124, 142, 163, 166, 170-172, 178, 179, 181-190, 194, 200-202, 206, 222, 228, 230, 236, 237, 239, 241, 244-246, 256-260, 266, 270

Artistic 2-4, 13, 18-20, 24, 31, 32, 36, 38, 53, 54, 58, 61-71, 74-77, 82, 87, 89-100, 118-121, 124, 162, 163, 165, 170-172, 178, 185, 186, 188-190, 200-202, 206, 227, 236-238, 250, 256

Artistic Research 18-20, 53, 54, 58, 62-71, 74, 75, 77, 82, 89-93, 95-100, 119-121, 124, 162, 163, 165, 172, 178, 185, 188, 189, 200-202, 206, 227, 236, 250

Artwork 3, 5, 6-8, 11, 12, 20, 25, 27-29, 34, 36, 60, 61, 63, 65, 66, 68-70, 75, 76, 90, 119, 120, 125, 126, 153, 162, 163, 165, 166, 170, 171, 176, 177, 178, 180, 182, 185-187, 194, 195, 206, 208, 230, 246, 257, 265, 266

C Commercialization 13, 32, 34, 178, 223

Community 5, 80, 88, 231, 247

Control 88, 225-227, 240, 262

Corporate 87, 222, 224, 238, 239
Criticism 3-8, 13, 18, 32, 34, 35, 37, 38, 60, 62, 71, 74, 80, 82-86, 90-92, 94, 95, 99, 170, 171, 225, 231, 235, 238-240

D Debate 3, 4, 14, 36, 64, 120, 194, 195, 238, 257
Dilettante 230, 234

E Encouragement 231, 236, 270
Entrepreneur 7, 74
Evaluation 4, 5, 65, 67, 225, 230, 232, 237
Experience 10, 24, 28, 30, 38, 39, 69, 71, 89-91, 93, 94, 170, 172, 181, 182, 188, 196, 232
Experiment 20, 27, 28, 88, 120, 176, 178, 185, 186, 188, 203, 226, 227, 229-232, 237-239, 244

I Ideology 7, 76, 77, 225-227, 281
Institution/institutional 2, 7, 13, 74, 77, 83, 84, 99, 119, 222-226, 228, 232, 234-240
Interdisciplinary 25, 38, 75, 119, 234, 237, 282

K Knowing 9, 12, 54, 85, 87, 162, 183-185, 189
Knowledge 8, 9, 12, 19, 32, 37, 63, 67, 70, 75-77, 80-83, 86, 88, 89, 91, 92, 94, 96, 99, 120, 121, 131, 162, 163, 184, 187-189, 196, 207, 208, 227, 231, 233, 239, 240, 256, 261, 263, 264, 266

L Language 4, 86, 93, 171, 202, 256
Legitimization 2, 225, 233, 241
Liberalism 224

M Market economy 7, 13, 18, 32, 34, 74, 226, 227, 238
Method/methodology 5, 20, 25, 26, 32, 33, 36, 38, 58-67, 70, 71, 80, 81, 83-88, 92, 95, 96, 100, 170, 171, 187, 188, 195, 196, 226-228, 232, 233,

235, 237, 239, 256, 258

Mimesis 5

Mind 8, 10, 53, 54, 91

N Neo-Liberalism 7, 133, 240

O Obstruction 227

Open-ended 65, 70, 71, 96, 121, 226, 227

P Paradigm 5, 37, 59, 80, 87, 95

Peers 20, 237

Politics 2, 3, 6, 20, 77, 93, 184, 202, 224

Power 59, 60, 63, 86, 96, 98, 100, 120, 151, 170, 223, 229, 230, 241

Practitioner 5, 24, 26, 27, 35, 82, 88, 89, 194, 201

Process 3, 12, 28-32, 61, 64, 65, 77, 81-83, 90, 91, 93-95, 100, 120, 154, 171, 179, 182, 187, 222-224, 226, 228, 229, 234-238, 257, 258, 262, 263, 266

Protest 222, 227

Public domain 3, 4, 18, 19, 65, 222, 231, 238

S Science 12, 19, 26, 32, 37, 39, 58, 59, 61, 64, 66, 71, 80, 87, 88, 91, 119, 178, 183-188, 251, 258, 259-265

Self-criticism 5, 6, 8, 60, 70, 77, 119

Self-doubt 10

Self-education 229

Self-empowerment 228, 231, 235

Strike 227

T Technocracy 223, 233, 234, 240

Thinking 2, 8-13, 74, 83, 85, 91, 92, 98, 99, 153, 178, 182, 183, 189, 200, 201, 266

Thought 2, 3, 5, 11, 12, 54, 119-121, 138, 178, 179, 182, 240, 258, 259

Tool 32, 37, 39, 170, 171, 173, 194, 224, 226-228, 232, 235

U Uncertainty 224, 263

University 2, 3, 4, 8, 24, 27, 32, 34-36, 66, 96, 172, 176, 184, 200, 222-224, 233, 236, 270

Colophon

See it Again, Say it Again: The Artist as Researcher
Editor Janneke Wesseling
Antennae Series n° 6 by Valiz, Amsterdam

Contributors Jeroen Boomgaard, Jeremiah Day, Siebren de Haan, Stephan Dillemuth, Irene Fortuyn, Gijs Frieling, Hadley+Maxwell, Henri Jacobs, WJM Kok, Aglaia Konrad, Frank Mandersloot, Aernout Mik, Ruchama Noorda, Vanessa Ohlraun, Graeme Sullivan, Moniek Toebosch, Lonnie van Brummelen, Hilde Van Gelder, Philippe Van Snick, Barbara Visser, Janneke Wesseling, Kitty Zijlmans, Italo Zuffi
Assistant to editor Tamara de Groot
Antennae Series editor Astrid Vorstermans
Translation Dutch-English Andrew May
Copy editing Rowan Hewison, Els Brinkman
Design Metahaven
Paper inside Munken Print 100 gr, hv satinated mc 115 gr
Paper cover Bioset 240 gr
Typeface Janson Text & Riccione
Printer Bariet, Ruinen
Published by Valiz, Amsterdam, 2011
www.valiz.nl

Colophon

Acknowledgments
Aernout Mik: photographs of his work by Florian Braun
Aglaia Konrad: photographs visual contribution are also published in: Aglaia Konrad,
Desert Cities (Zurich: JRP|Ringier, 2008).

Distribution
USA: D.A.P., www.artbook.com
GB/IE: Art Data, www.artdata.co.uk
NL/BE/LU: Coen Sligting, www.coensligtingbookimport.nl
Europe/Asia/Australia: Idea Books, www.ideabooks.nl

This publication was made possible through the generous support of
University of the Arts, The Hague, the Netherlands
Mondriaan Foundation

Mondriaan Stichting
(Mondriaan Foundation)

Hk Hogeschool der Kunsten
Den Haag University
of the Arts The Hague

ISBN 978-90-78088-53-0, NUR 646
Printed and bound in the Netherlands, 2011

303

Other titles in the Antennae Series:

The Fall of the Studio: Artists at Work
edited by Wouter Davidts & Kim Paice
Amsterdam: Valiz, 2009, ISBN 978-90-78088-29-5

Take Place: Photography and Place from Multiple Perspectives
edited by Helen Westgeest
Amsterdam: Valiz, 2009, ISBN 978-90-78088-35-6

The Murmuring of the Artistic Multitude: Global Art, Memory and Post-Fordism
Pascal Gielen (author)
Amsterdam: Valiz, 2009, ISBN 978-90-78088-34-9

Locating the Producers: Durational Approaches to Public Art
edited by Paul O'Neill & Claire Doherty
Amsterdam: Valiz, 2011, ISBN 978-90-78088-51-6

Community Art: The Politics of Trespassing
edited by Paul De Bruyne, Pascal Gielen
Amsterdam: Valiz, 2011, ISBN 978-90-78088-50-9